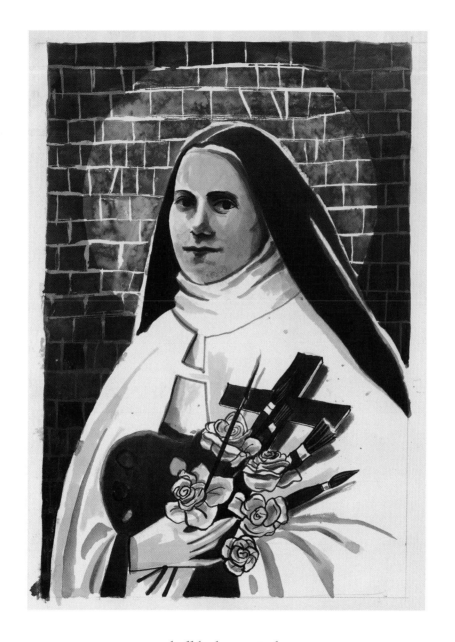

I shall be happy in heaven
if you compose some pretty verses for me;
it seems to me that this must give pleasure to the saints. (LC69)

Journey with Thérèse of Lisieux

To Marie

In St. Therese,
your patron and friend—

Michael W. McGrAth

Journey with Thérèse of Lisieux

Celebrating the Artist in Us All

Artwork, Selections, and Text by

Michael O'Neill McGrath, OSFS

Sheed & Ward
Franklin, Wisconsin

As an apostolate of the Priests of the Sacred Heart, a Catholic religious congregation, the mission of Sheed & Ward is to publish books of contemporary impact and enduring merit in Catholic Christian thought and action. The books published, however, reflect the opinions of their authors and are not meant to represent the official position of the Priests of the Sacred Heart.

2001

Sheed & Ward
7373 South Lovers Lane Road
Franklin, Wisconsin 53132
1-800-266-5564

Library of Congress Cataloging-in-Publication Data

McGrath, Michael O'Neill.
 Journey with Thérèse of Lisieux : celebrating the artist in us all / artwork, selections,
 and text by Michael O'Neill McGrath.
 p. cm.
 ISBN 1-58051-088-4 (alk. paper)
 1. Thérèse of Lisieux, Saint, 1873–1897. 2. Thérèse of Lisieux, Saint,
 1873–1897—Pictorial works. 3. Spiritual life—Catholic Church. I. Title.

 BX4700.T5 M38 2001
 282'.092—dc21

 00-051588

1 2 3 4 5 04 03 02 01
Printed in the United States of America

To Sister Mary McGrath, SSJ,
and to the Sisters of Visitation in Minneapolis,
sisters and friends always,
who have companioned me on my journey

Contents

Introduction *xii*

1. *Fishing in Her Father's Wheelchair 2*

2. *Fishing for the Good News 4*

3. *Zélie Martin Making Lace (Insert: The Funeral of Thérèse's Mother) 6*

4. *Art Lessons (Insert: Thérèse Fishing with Her Father) 8*

5. *Trouville Beach: Sails in the Sunset 10*

6. *Pilgrimage 12*

7. *The Mystical Bride 14*

8. *A Hidden Life behind the Cloister Grille 16*

9. *The Carmelite Family 18*

10. *Thérèse and the Child Jesus (Insert: Swinging with Jesus) 20*

11. *Doing the Dishes and God's Work 22*

12. *The Chasuble 24*

13. *Joan of Arc 26*

14. *Charity toward All in the House (Insert: Thérèse in the Prayer of Repose) 28*

15. *Elevator 30*

16. *The Tabernacle 32*

17. *Writers' Seminar 34*

18. *Writing Poetry with John of the Cross* 36

19. *The Garden Within* 38

20. *Eagle (Insert: Sparrow)* 40

21. *Mural Painting* 42

22. *The Palette of the Divine Painter (Insert: Thérèse the Painter)* 44

23. *Thérèse Soars while Clinging to the Cross (Insert: Thérèse with Her Head in the Clouds)* 46

24. *Living Flame of Love* 48

25. *Thérèse and the Lord of the Dance (Insert: Embraced by the Sacred Heart)* 50

26. *First Signs of Blood (Insert: Coughing Like a Locomotive)* 52

27. *The Dark Night of Thérèse's Soul* 54

28. *Thoughts of Suicide (Insert: Faces)* 56

29. *Jesus Comes to Thérèse* 58

30. *The Warrior Is Lifted from Her Bed* 60

31. *Over the Wall* 62

32. *Heaven* 64

33. *Shower of Roses* 66

Conclusion 68

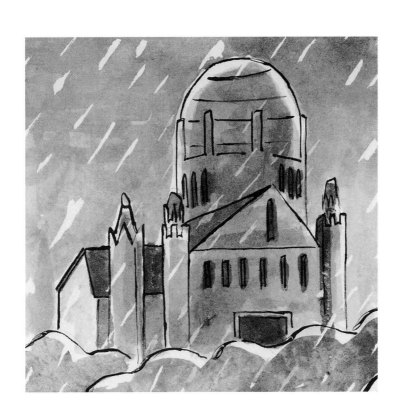

Introduction

*T*hérèse started this whole thing, not me. It's always been my experience, ever since I began to believe these things in my Catholic boyhood, that particular saints come to us at particular times of need. I think the saints get together and say, "I'll do duty for a while because I have just the thing for this person."

Thérèse Martin (1873–1897) had never really been a saint of my devotion, however. For most of my life, in fact, I thought of her as a little doll in a nun's outfit (Sister Barbie) with nothing of interest to say to me. She was for teenage girls and little kids. I hadn't read her works, or anything about her for that matter, so my disdain for her was based solely on the visuals: too much pink and too many flowers, like icing on a cake; Thérèse, the plastic statue with made-up eyes holding a bouquet of roses like "Miss Lisieux."

But all that has changed. Thérèse is now one of my best soul-friends. My heart takes a little leap when I encounter her in the niche or window of a candle-lit church, much like those times when I come unexpectedly upon a picture of my dead parents or see a piece of their handwriting. Those are moments—and tugs—that can give a heart pause.

The first of four or five times that I have read Thérèse's autobiography, I was living in a tent for two weeks by the Wenatchee River in the Cascade Mountains. It was the summer following my father's death, and I was there to teach an art and prayer workshop at the Grunewald Guild, a Christian art community to which I'd been going for several years. What was I thinking? The annoyance of bugs, the fear of mountain lions, and my only reading material—*Story of a Soul*, a book about a young woman dying of tuberculosis—matched my own ongoing crabby and melancholic mood at that time in my life. I remember thinking of the book as one of those obligatory classics you have to read. So you can imagine my surprise when, sitting in the sun like a lizard outside my tent, I discovered that Thérèse's words and stories had an earthy simplicity that appealed to me. I began to translate them on paper as sketches and pieces of calligraphy—and then I put Thérèse in the back of my mind. It was a slow but steady start to a solid relationship.

The deal has always been that one receives roses—actual roses or perhaps a simple picture or image of roses—after praying to Thérèse for a good week or so. I got my own first rose several years later, following another week of inner angst and brokenheartedness. (Welcome to my world.) There I was, giving a workshop at a retreat center. After waxing eloquently to the group about the healing power of art, I headed straight for my room and languished. There I busily addressed all the entries in my prayer journal to Thérèse, starting them with "*Ma Chere* Thérèse, Here we are, another day of torture" or "*Ma Chere* Thérèse, Help. *Vite, vite, s'il vous plait.*" Also during that time, I did sketches and small paintings of scenes from Thérèse's life. In my initial ones, she was always deep in contemplation or dying, which is pretty much all she did, I suppose, when you really look at it. (Pretty much what any of us ever do, I suppose, when you *really* look at it!) Anyhow, when I got home from the retreat, a rose was waiting for me in an odd and unexpected way. It was nestled in a letter that I received from

a friend in India whom I hadn't heard from in a year. There, on the second page of his letter, without any explanation, he had drawn a picture of his hand extending a rose—and I knew I was hooked. I immediately went to a local purveyor of church tchotchke and bought myself a large statue of Thérèse, harnessed her in the passenger seat of the car, and drove her home. (No, I didn't talk to the statue.)

Ever since that time, Thérèse has been looming in the rear window of my studio, an ongoing source of inspiration and encouragement. "Draw me," she seems to be saying over and over. "Draw me and you will be drawn to God. Draw my littleness and you will discover your own littleness and you will find a small patch of heaven in your heart. Draw me and you will not feel so alone." Gradually, I began reading Thérèse's journal again, as well as other books about her: her last conversations, her poetry, biographies about her sisters.

Artists can become infatuated at times with their models. Sometimes a person's face or spirit reaches out to an artist's heart with a mysterious tug of recognition, or a certain place exposes a hidden sense of nostalgia and longing. The process of sketching and painting helps us better understand the reason for this, bringing us closer to the Truth. Thus, I began to think of Thérèse as a muse guiding me to new depths of self-awareness. Such is the mission of an artist's models and saints alike. And, as an added benefit, I didn't have to pay her by the hour.

Eventually, as if caught in an affair way over my head, I decided to visit Lisieux, France, following a two-week pilgrimage to the holy places of St. Francis deSales, the patron of my religious community. The pilgrimage actually began in the French Alps, in St. Francis's hometown of Annecy, and ended in Paris, where I waved *au revoir* to my fellow pilgrims and journeyed onward alone to Normandy.

I had very mixed feelings in my heart, which, of course, comes with pilgrimage. On the one hand, I was most anxious to see at last the homes where my dear friend hung her halo. On the other hand, however, I'd grown increasingly impatient with all those French people not speaking English. Plus, my sketchbooks seemed to plead with me, "Please, no more churches or cathedrals. We can't handle another one." Even as I prayed for a second wind to carry me through the next and final week of my journey, my pilgrim heart was beginning to long for home.

I stayed in a monastery in Caen, the former home of Thérèse's sister, Léonie, the only one of the five Martin sisters who wasn't a Carmelite. Having made several ill-fated attempts to become a Carmelite, Léonie became a Sister of the Visitation, the order founded by Francis deSales and his best friend, St. Jane deChantal. (It was a Visitation nun who co-founded the congregation of men to which I belong.) Léonie was the troubled middle child of the family, the odd duckling who matured into a beautiful, humble swan, and is considered the first person to truly live out the "little way" taught by her more

Léonie Martin/Sr. Francoise Therese. June 1, 1999
Caen Visitation

famous baby sister. As a blood sister to Thérèse and a spiritual sister to me, Léonie seemed the obvious choice to host me and make the proper introductions.

I arrived at 5:30 in the evening hoping for dinner—but I got Mass instead. But what a liturgy it was! I entered the chapel just as six Visitandine nuns were dancing up the aisle with offertory gifts, the beat of African drums and chant reverberating through the baroque chapel. I discovered later that twenty-five nuns were living in the monastery—refugees from Congo escaping the ravages of civil war at home.

Although the nuns continued to play their drums when Mass was over, one of the elderly French Visitation nuns, tiny and bent over with osteoporosis, began cleaning the sanctuary. Before long, however, she was dancing and swaying to the drumbeat—gliding around the sanctuary with the chalice in her hand, just like the warrior and priest Thérèse always wanted to

be. I knew that this spectacle had been arranged for me personally by the Spirit, and that for the next four days this would be my home.

I went to Lisieux for just one day, filling my sketchbook with fifteen new pages of inspirations gleaned from what I saw at the basilica erected in her honor; from Les Buissonets, her childhood home; from the local cathedral of St. Peter, where she discovered inside herself her vocation; and from her tomb and small museum at the Lisieux Carmel. At the end of the day, with an hour to kill before boarding my train and returning to Caen, I stopped for a few beers and sketched the rainy view of the basilica crowning the highest hill. That moment inspired the drawing on page xiii, which, more than any other, expresses my entire Thérèse experience. (Please note that Thérèse, good French woman that she was, is enjoying a glass of wine instead of beer.) Because I'd read a quote of hers—"I will be your friend and sister always"—I drew the two of us together, having a

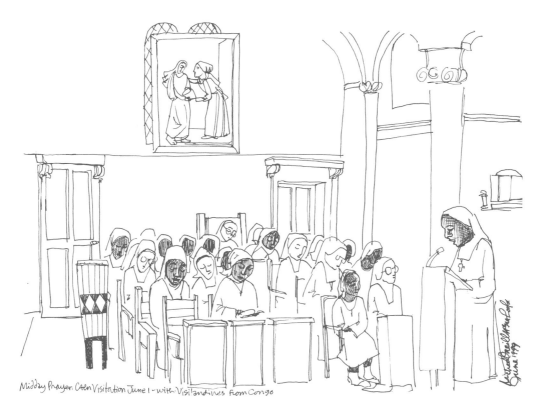

Midday Prayer. Caen Visitation June 1 - with Visitandines from Congo

farewell drink. I was expressing my hope that she'd said that just for me.

Later that year I took a brief sabbatical and lived as an anchorite to a small monastery of Visitation nuns in Minneapolis. ("Join the religious life and see the world" is my motto.) Armed with books, sketches, memories, and a thousand ideas in my head, I began there the series of drawings that are the substance of this book. The more I wrote and read, the more sepia-tinted drawings I created, and the more meditating and walking I did around the lakes of the Twin Cities, the more I came to a deeper awareness of why Thérèse has meant so much.

In my prayer journal I drew a metaphor to help me: a mining car. The sketch shows Thérèse and me, helmets on our heads and flashlights in hand, sitting in a mining car ready to descend. As I held this image in the foreground of my mind for several months, I often wondered where the car would lead in its dark descent. Following Thérèse's lead, I found myself praying my way back to childhood and doing a painting of my first studio.

When I was twelve years old my parents created a studio for me in the basement of our home. My easel was an old linoleum-topped kitchen table facing a concrete wall, and my ideal northern light was a fluorescent desk lamp that

emitted an obnoxious buzzing sound. Dank and damp as it was, that basement studio became my refuge. For many years it was the first place I'd head when I got home from school—my very own space, a gift from two supportive parents who encouraged my artistic explorations.

I see now, with middle-aged eyes, that it was there, in that studio/oratory, that I first grew aware of God's presence in my heart; it was also where I discovered how to find rest in the heart of Jesus. That shadowy space in the bowels of my childhood home was where I learned to put on paper the colors, shapes, and lines of my spirit (copied pictures from *MAD Magazine* and my children's Bible). I also learned, there in that damp cellar, that when I am alone creating, I am never *really* alone.

These drawings, completed over a six-month period, are like meditations in a mining car. In doing them I was led into the recesses of my heart, where I encountered Christ in flesh and blood; where I discovered more love than fear; wherein dwell my mother and father and the whole communion of saints, just as I learned as a young boy. I believed it then, I believe it still.

This book is a spiritual travelogue of sorts, a series of postcards and messages from my journey to the heart of a mystic. Thérèse—the mystic who loved to sketch and paint, who wrote poetry and plays, and who saw with artist's eyes the beauty of the ordinary— revealed to me some new faces of Jesus, the innocent child alongside the ravaged face of sorrow. Through her writings and paintings Thérèse leaves each of us a lesson worth remembering: in the dark cellars of our hearts, waiting to be drawn out to the light of day, are the words, shapes, and colors of our memories—memories of God and memories of love. I hope you find in Thérèse what I have found: a friend who gently guides us into the depths of ourselves and the loving arms of God.

1. Fishing in Her Father's Wheelchair

I am not breaking my head over the writing of my little life.
It's like fishing with a line:
I write whatever comes to the end of my pen. (LC63)

Through writing, Thérèse found a way to open doors to her past so that she could better understand her present. The process of writing, or of any creative process for that matter, gives us the clarity we need to do just that. It gives us the opportunity to see our lives in black and white, helping us to sift through the overwhelming clutter of details and stories that live inside of us and sort them into more manageable parts. It also helps us dismantle the walls of fear that surround our hearts like fortresses. Every word and stroke of the pen helps remove another brick.

As I proceeded through this series of drawings, one image haunted me more than any other: the picture of Thérèse writing on her laptop desk while sitting in her father's wheelchair in the cloister garden. Thérèse was very devoted to her father, whom she called her "king," and was pleased to have his personal effects, including his wheelchair, brought to the monastery after his death. Seated in this relic, the throne of her father's last years, Thérèse was able to explore her inner depths in security and peace (except for the well-meaning nuns, of course, who would torture her with interruptions). Here, in the shade of the trees in the cloister garden, her father was with her, guiding her pen as it fished in the fertile streams of love and memory.

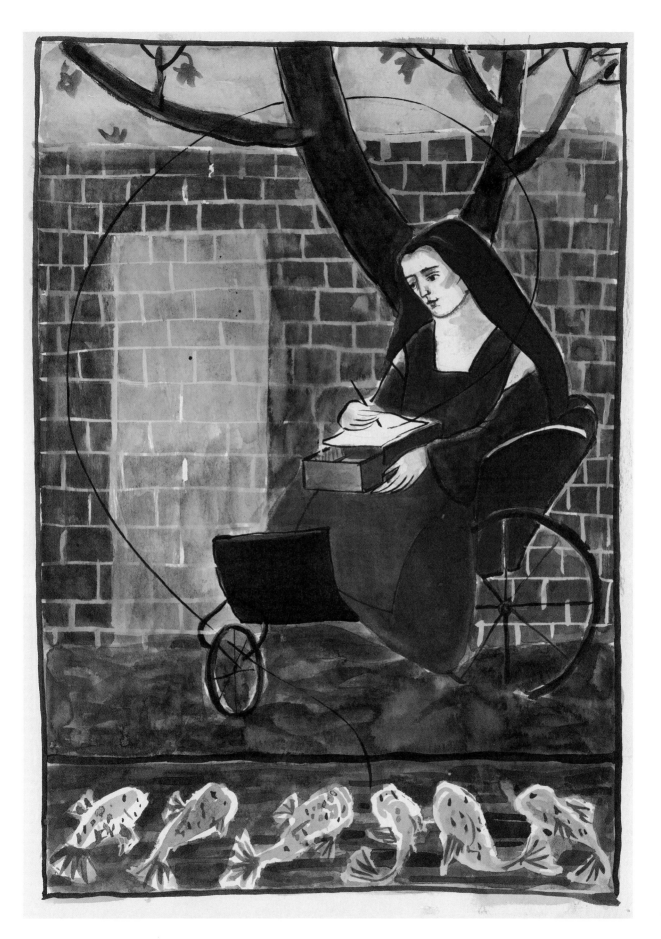

3

2. Fishing for the Good News

I am writing the story of the Little Flower gathered by Jesus.
I will talk freely and without any worries. (SSC15)

When she started recording scenes from her life in a notebook, Thérèse, I'm sure, had no idea that she was writing the best-selling spiritual work of the twentieth century. A teeny bit of pressure like that just may have inhibited her ability to write so freely. Instead, she wrote for her own personal fulfillment, without concern for style or artfulness, free of any need for recognition or acclaim. Without the distraction of perfectionism lurking over her shoulder, she laid her soul bare.

I see Thérèse as a scribe writing the dictations of the Holy Spirit, just as the four Evangelists were depicted in medieval illuminations—the Holy Dove shown whispering in their ears while their pens glide across the page with the Good News. We all have good news to write. Each of us, in fact, is an evangelist called to listen in our heart to the whispers of the Holy Spirit—whispers of annunciations and incarnations, of passions and deaths that flow through our veins and flood our memories.

The sacred is made flesh in our own lived story. No matter how ordinary or nondescript we find our own lives, no matter how filled with passion or turbulence, it's a good and holy idea to take pen in hand and get it all down on paper. Love is revealed to us in words or pictures, in black and white, in color. When fear is enlightened by love, the ending of the tale is always the same: resurrection.

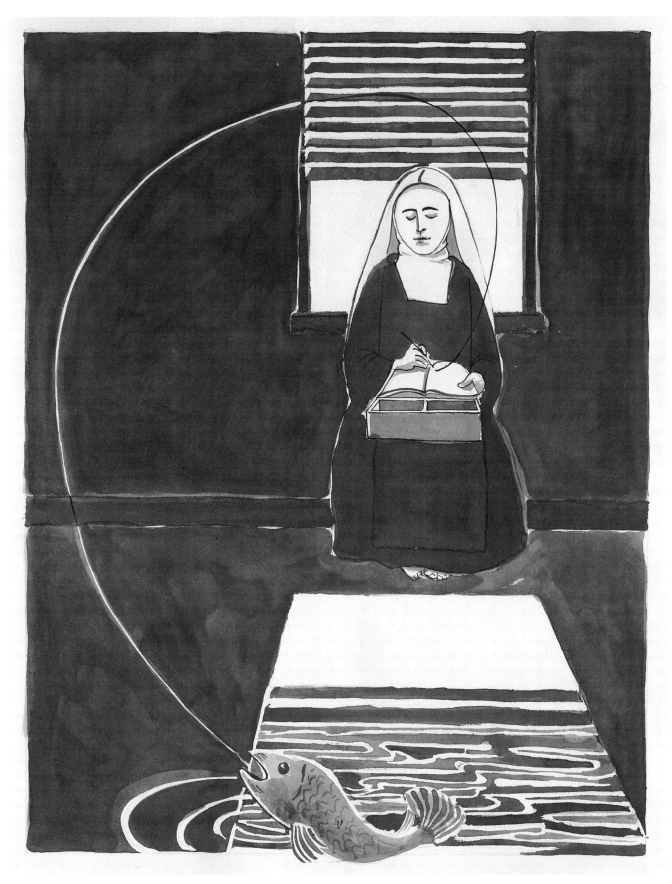

3. Zélie Martin Making Lace

My happy disposition completely changed after Mama's death.
I, once so full of life, became timid and retiring,
sensitive to an excessive degree. (SSC34)

One day several years ago while setting up a neighborhood lawn party, our next-door neighbor's eight-year-old daughter asked me, "Mickey, what about the people that just want to be alone? Shouldn't we put chairs off to the side for them?" A kid after my own heart! This pint-sized contemplative, this artist in the making, grasped already what Thérèse also knew at that same age—and what takes most people many years to discover (those fortunate enough to discover it at all): it's okay to be alone because we never are really alone. In fact, being alone can be downright preferable.

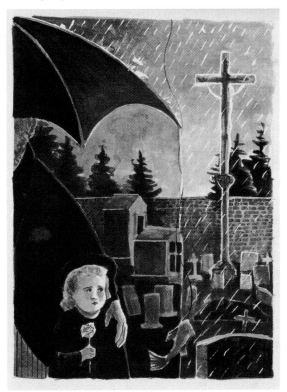

Zélie Martin, Thérèse's mother, a lace maker who had her own business, died of breast cancer when Thérèse, the youngest of five daughters, was only four years old. Such epic loss ushered Thérèse through a new threshold that made her acutely aware of life's transience and the unbearable sadness of love, an awareness that would dictate the course of her life. Thérèse crossed that threshold with a heart full of memories and a head full of details: last words and conversations; prayers around the sickbed and coffin; images that would be with her forever.

Somehow, no matter what age we are when our mother dies, we pull ourselves together and we get by. Momentous loss brings equally momentous blessings. For Thérèse, her lifelong search for a mother's love led her to discover a material and gentle God, something radically different from the images of God so prevalent in her day. She once told a teacher that she loved to be alone and think about eternity. Understandably, the teacher laughed (as I did at the lawn party); we simply aren't accustomed to such wisdom from the mouths of babes. Thérèse later said her school years were the most painful of her life—but they were also the years when she discovered the wide open mother-loving arms of God, and found within those arms something permanent and unshakable.

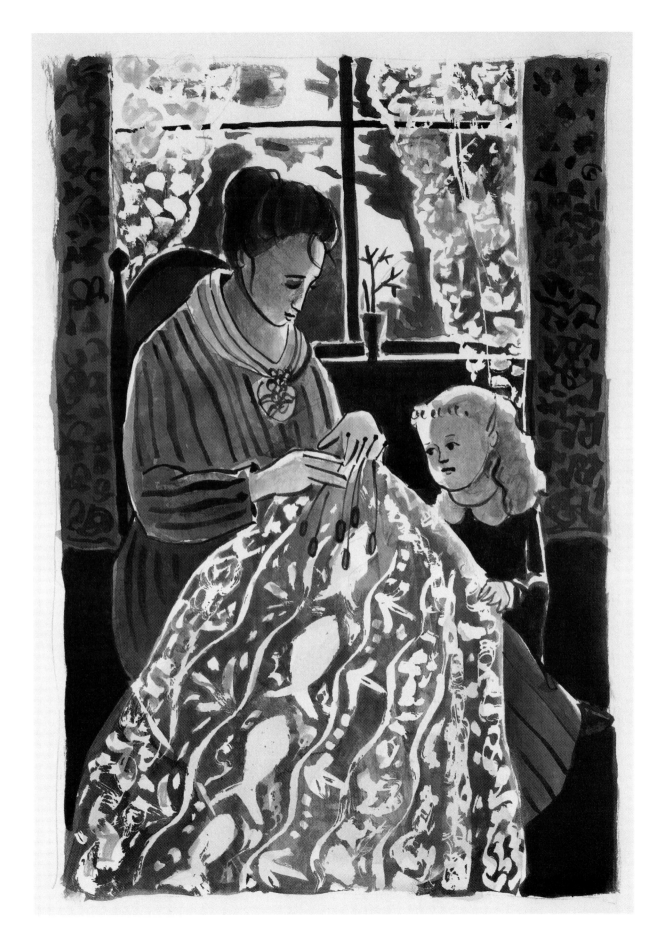

4. Art Lessons

Earth then seemed to be a place of exile
and I could dream only of heaven. (SSC37)

Thérèse was very devoted to her father, Louis. She wrote of their walks together on Sunday afternoons and of how he would take her along when he went fishing. One day he asked her if she would like to take drawing lessons, as her older sisters had done. Just as she was about to reply "yes," one of the Martin sisters piped in with her two centimes and pointed out that there was "enough kids' art around the place already, thank you very much, and just what will we do with more of it?" The poor thing was probably just having a bad day, but her remarks were enough to silence the young Thérèse.

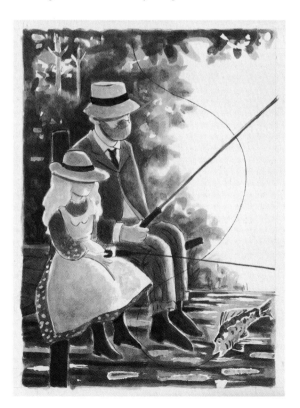

We all have, no doubt, some looming figure in our childhood who had a little too much to say and nipped our dreams in the bud: an art teacher who said you were lousy with colors; a meddlesome neighbor who said you were too klutzy to dance; a parent who insisted that there's no money in playing the French horn; a crabby confessor who convinced you that you were the child of Beelzebub.

In the instant it takes to make an offhand remark, the inner light of talent can be covered with a bushel basket so big that it takes years of therapy or spiritual direction to lift it off. Creative activity is the best way to be still and see that light, which actually has been only hidden, not extinguished. Our talents are the light of the Holy Spirit summoning us upstairs from the dark cellar of our fears, above our dependency on the alcohol or drugs, the food or sex, the workaholism, or the complacency that has numbed our senses and dimmed the light of our in-born giftedness. It is in that light—the light of the Holy Spirit—that we see Light Itself.

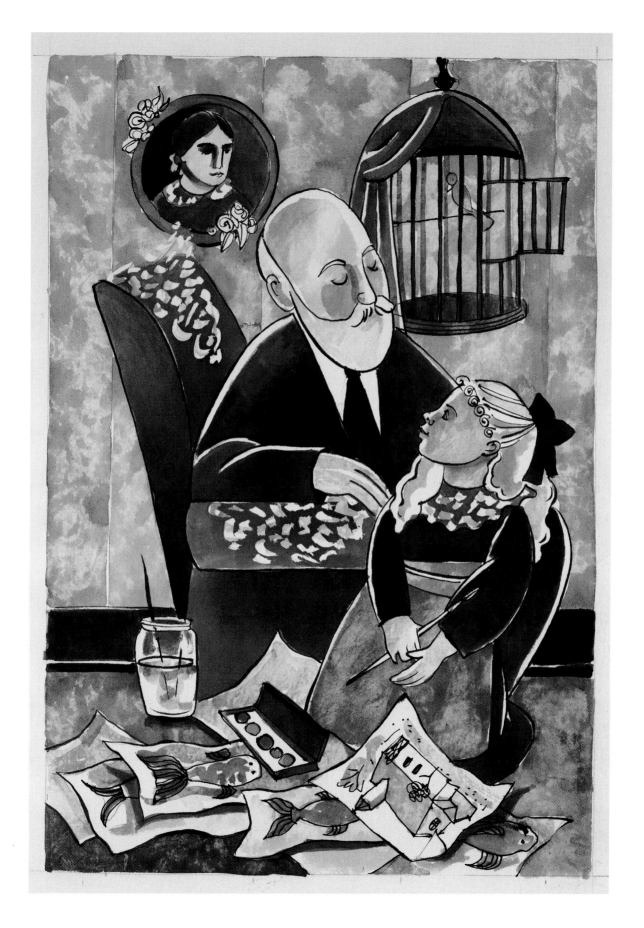

5. Trouville Beach: Sails in the Sunset

The image of a ship always charms me
and helps me to endure my exile. (SSC87)

*L*ike meditation, sketching and writing make us more observant, focusing our attention on the tracings of God in nature. While we are engaged in the process of sketching, we become one with what we draw, seeing things we never noticed before. The world springs to life for the first time, right before our eyes, and teases us into a response. "Watch this lightshow," it seems to say, "and see what you can do with it."

As a child, Thérèse once visited the Normandy beach resort of Trouville, where she did a sketch of a boat sailing toward the setting sun. Since the Impressionists also went there to observe the light, it is fun to consider that just maybe she bumped into Renoir doing charcoal sketches on the boardwalk, or that she stopped to observe Monet painting by the shoreline. Like them, she was probably entranced by the fleeting beauty of light. But for her it was different.

The Impressionists saw the transience of light and what it did to the surfaces of reality. For example, they examined the flickering light of the sun dancing on constantly shifting tides, and they were excited by pure, clear light on foamy waves and billowing clouds. Theirs was art for art's sake, and their main concern was which brushstrokes and colors best expressed what they so scrupulously observed on the surface of the world.

Thérèse saw these same things but through a different filter, steeped as she was in the sacraments and symbols of Catholic devotional life. When Thérèse watched the light of the setting sun, for example, it was no less than Jesus, the Light of the World. As she watched a sailboat glide toward the dusky horizon, it became her exiled soul striving to get home—a metaphor she would recall in poems and sketches throughout the rest of her life. For Thérèse, the light of the sun and the darkness of the ocean depths were lasting images that guided her to the seascape of her soul.

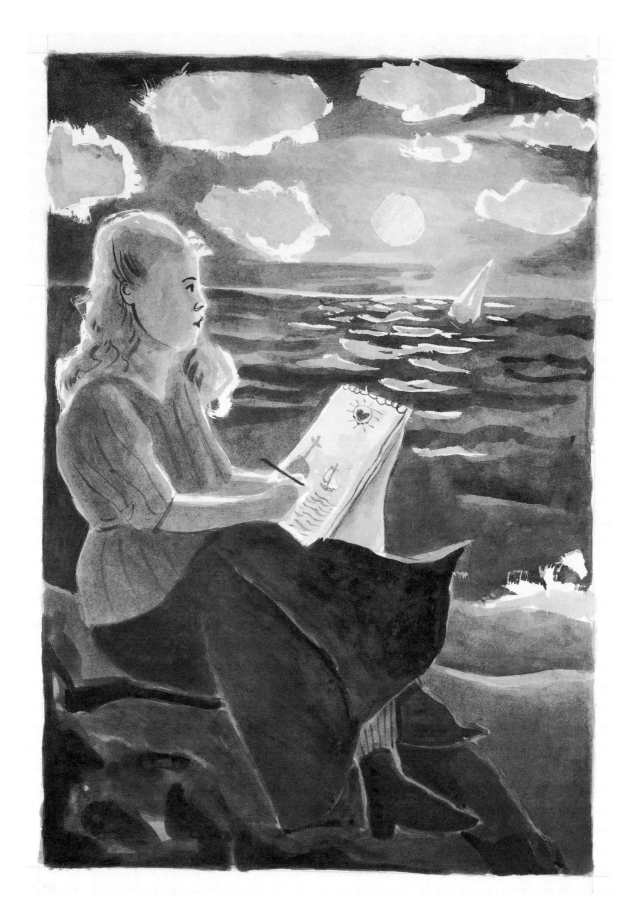

6. Pilgrimage

I contemplated all the marvels of art and religion; I trod the same soil
as did the holy apostles, the soil bedewed with the blood of martyrs.
And my soul grew through contact with holy things. (SSC121)

The year before she entered Carmel, when she was fifteen years old, Thérèse made a pilgrimage to Rome; it was the first and last time she would leave her little Norman corner of the world. She walked the streets of great cities—Paris, Florence, Milan—and explored their art. She gazed in wonder at the Alps, the olive trees of Provence, the hills of Assisi. In Rome, she kissed the ground of the Colosseum and, breaking all rules of decorum, literally threw herself into the lap of an astonished Pope Leo XIII to ask his permission to enter the monastery before the required age. She was physically lifted off the old guy and carried away by the Swiss guards, but several months later received her permission.

Pilgrims never travel alone. They carry with them the memories of loved ones who have gone home before them. They also carry the spirits of those whose talents built the cathedrals, painted the icons, carved the stones, and created the stained glass windows that delight the pilgrim's heart along the way.

Spiritual pilgrims and artists share a common experience of heightened awareness. When our hearts are enlivened by beauty and stirred by memorable things, we are led to a deeper awareness of ourselves and our capacity for inner peace. Our eyes see the surface of the world, our hands wish to touch it, our minds help us process it, our souls look for what lies beneath, and our hearts weave these details into the fabric of memory.

On the first day of a pilgrimage I went on, the leader announced to the assembled group that the pilgrimage wouldn't actually end at the destination to which we were headed, which was Santiago deCompostela. Rather, our pilgrimage would end where all pilgrimages end, which is where they begin: at home. Pilgrimages, no matter how small or great the distance traveled, are about the journey itself, the difficult steps, the lessons learned along the way, the annoyances and inconveniences as well as the hushed moments of awe. Pilgrimages, like art, fill us with grace—which guides us home.

13

7. The Mystical Bride

Now I have no other desire
except to love Jesus unto folly. (SSC 178)

Like many of her fellow mystics throughout church history, Thérèse had a great love for the Song of Songs, that great book of the Old Testament that uses the imagery of romantic love to describe the yearning of the human soul for God. Meditating on its poetic content fed Thérèse with symbols for her own writings, in which she described herself as the mystical bride of Christ. She desired no one else but Jesus, speaking of Him as her fiancé, the only Lover whose face

Mantle profession

could delight her eyes and who brought her precious gifts. Theirs was a love affair as passionate as any affair of the heart and flesh. It was in His embrace alone that Thérèse longed to be hidden for the rest of her time on earth.

Lovers and poets are people who live in an eternal state of desire. Their souls are restless until they attain that which they so ardently crave. Out of that pool of restlessness and yearning comes the erotic energy that fills their poems, paintings, songs, and other creative expressions with passionate love. Erotic energy ignites in us the need to be connected to another, even Jesus, as well as the need to somehow express this yearning.

That's how Jesus was to Thérèse, and to most other saints as well, I suppose. Jesus filled every present moment, every glance, every dream, every wild and passionate imagination. It wears me out to think of it that way, but I suppose that's what happens when we attempt to express the holy. In drawing God, we draw God nearer to ourselves. In the creation of our artistic expression, we come face to face with our deepest desires, where hearts speak to other hearts.

shoes

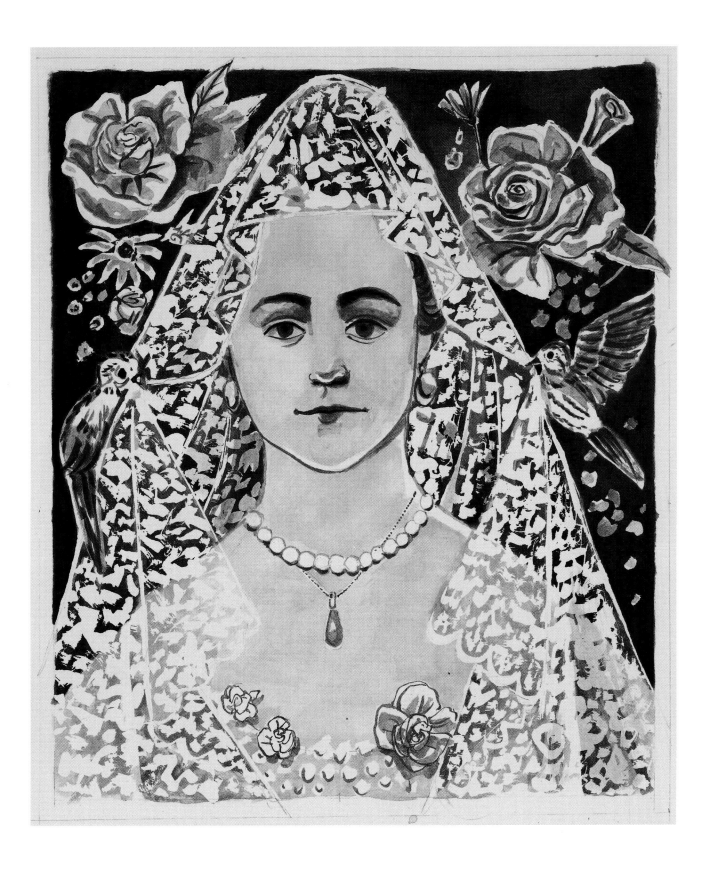

8. A Hidden Life behind the Cloister Grille

Joy is found in the inner recesses of the soul.
One can possess joy in a prison cell
as well as in a palace. (SSC137)

Here she is, caught between the proverbial rock and a hard place. Thérèse thought of the Carmelite monastery as a prison—and when she spoke with joy of the prison doors opening, it was so she could enter, not flee! Thérèse was a willing prisoner, deliriously happy to be confined in such a refuge. The world behind the cloister grille was a place to live her life to the fullest, where she could grow into the person she was meant to be, a flower in a hothouse (in her case, a rather damp and cold hothouse). There she was in a safe place, hidden away from all that could take her heart in custody from her one true Love: God. In her prison, Thérèse found ultimate freedom.

By their very nature, creative spirits must assert themselves in the face of restrictions. It is an inherent trait, the need to soar above any hurdles put in their way. Ever since the early days of the Church, saints and hermits have retreated to desert and wilderness to listen to the whisper of the Spirit in their souls. For painters and writers this happens on canvas or paper. Vincent van Gogh, for example, looked up to the sky from his insane asylum and painted his meditation on a starry night; Anne Frank hid in an attic and recorded her feelings in a diary that moved the world; African-American slaves composed great music—the spirituals—with shackles on their legs; Georgia O'Keeffe did her best work while living as a recluse in the desert.

Most of us live in self-designed prisons of one sort or another. It is up to us to decide if the doors inhibit us or set us free.

Model of Carmel

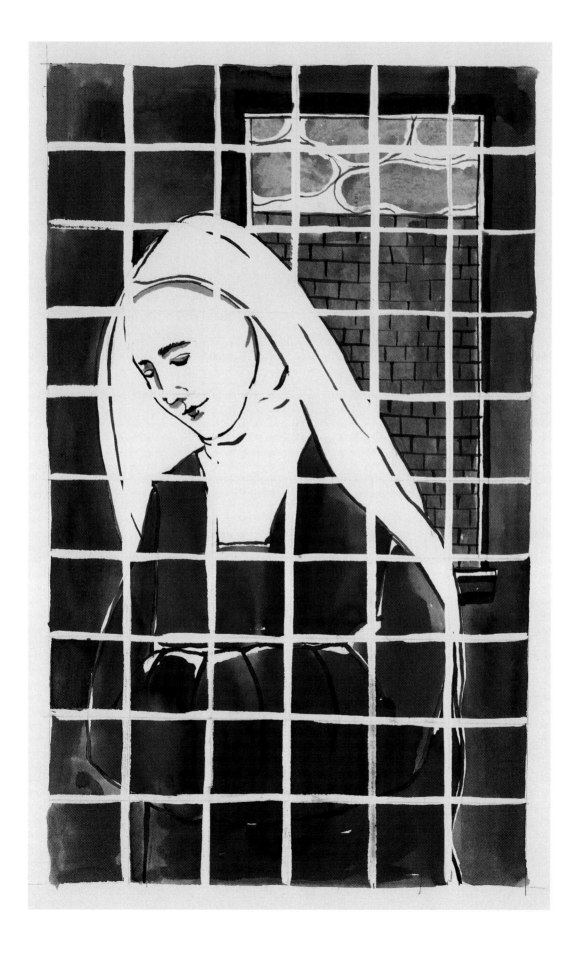

9. The Carmelite Family

O blessed inhabitants of heaven,
I beg you to adopt me as your child. (SSC196)

My favorite moment in a religious profession ceremony or ordination is the singing of the Litany of Saints. The roll call of saints throughout church history, and our humble beseeching of their help, is a most meaningful prayer experience for me, and it always leaves me teary-eyed.

Picture this: heaven is a vast adoption agency, and we are the love-starved orphans waiting to be selected. Saints, usually in pairs, stroll around the aisles of this big orphanage we call Earth, picking and choosing from the wide array of us big-eyed and tattered children who are in search of a new home. There is Benedict and Scholastica, for example, making the rounds alongside Francis and Clare. There's Vincent and Louise bargaining with Francis deSales and Jane deChantal, and there's Ignatius, a single parent in the market for little soldiers. And there's Martin dePorres and Rose of Lima looking for color to spice up their black-and-white Dominican world. Heaven is filled with adoptive parents looking for the perfect kid.

When I was discerning which religious order to enter, at the ripe old age of seventeen (it's hard to imagine now!), I first chose the Franciscans because I always liked those brown habits and cords. (I even got as far as taking the psychological test for them, which I actually passed.) But the wind of the Spirit soon began to blow my sails in another direction, and I ended up in the Salesian family as an Oblate of St. Francis deSales.

A wise monastic nun once told me that we are led to that spirituality which best feeds our own private hungers. We each need to find—or be found by—a spiritual family who can companion us on our spiritual pilgrimage. They feed us, hold us up, and carry us along when we're weary—and they let us know when we're acting like idiots. They make us feel connected to each other, to the world, and to God.

Spiritual families give us a sense of identity. Saint Francis deSales said, "Be who you are and be that perfectly well." The proper soul family helps us do just that. Thérèse made the ascent to Mt. Carmel and discovered Teresa of Ávila and John of the Cross waiting for her beneath the mantle of Our Lady of Mt. Carmel—and knew she had found her home.

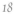

10. Therese and the Child Jesus

I wanted to amuse Jesus;
I wanted to give myself up to His childish whims. (SSC136)

Thérèse's favorite concept of Jesus was the Christ Child. In fact, she wanted to be His toy. She wanted to hold Him in her arms and put her own cradle next to His. When the sailboat of her spirit was caught in stormy seas, she imagined Him napping peacefully at her side.

Thérèse's favorite statue in the monastery was one of the Christ Child. As the artistic one in the community, Thérèse had the responsibility of retouching the paint when it needed some work. Thérèse called this statue her "little pink Jesus." (It now stands next to her tomb.)

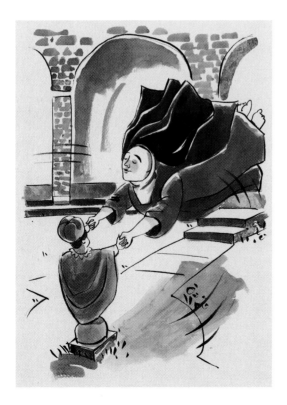

This really scared me!

Because Thérèse always promised she would lead souls to Jesus, I was afraid that she had the little pink one in mind. She was going to bring me to the little French butterball with golden curly locks on the front of every bad Christmas card you've ever received—the Jesus whose parents look like Barbie and Ken in Bible clothes. This is not exactly the picture I could sink my adoring teeth into. Nothing against babies, the French, or otherwise, but let's face facts: Jesus was born a little south of France in a garage for donkeys.

I needn't have worried. The Jesus Thérèse has led me to is all mine, not hers. Actually, to be more truthful, Thérèse has pointed me toward the Jesus who is God incarnate, bigger and broader than any God our own feeble minds can conjure up. A baby Jesus who breaks down all barriers that separate believing souls. A baby Jesus who is fully human, male and female of all colors.

The Christ who is forever Child and forever free.

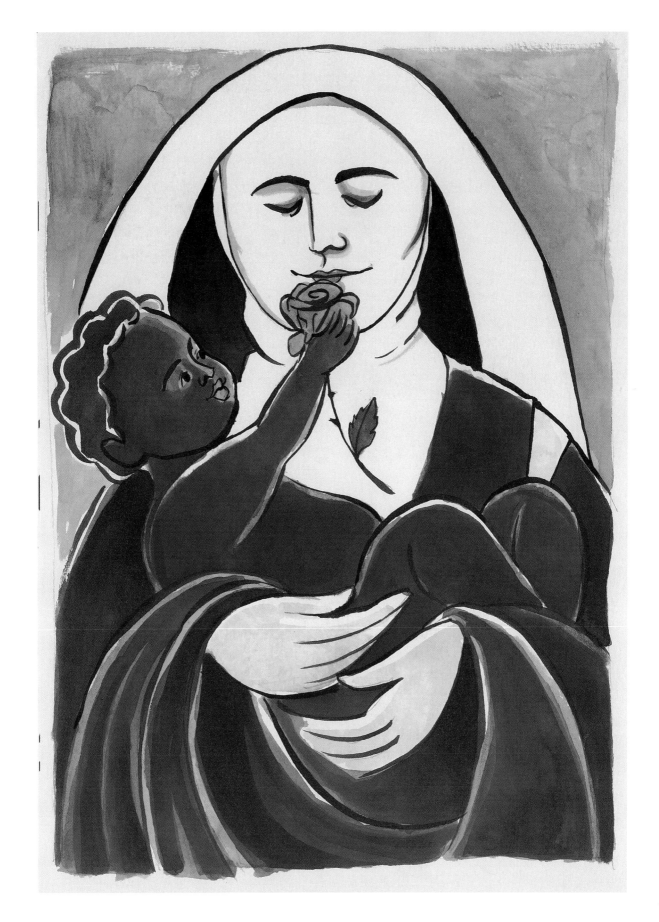

11. Doing the Dishes and God's Work

I find just when I need them certain lights . . .
and it isn't during my hours of prayer that these are most abundant
but rather in the midst of my daily occupations. (SSC179)

A calligraphy teacher of mine would repeat the mantra: "Make every stroke intentional." In fact, he said this mantra so much that I feel it is written in beautiful, flowing calligraphy on the sides of my heart. I've always suspected that this wise man wasn't talking about just the creation of beautiful letters, however; rather, I believe he was revealing to us the secret of life. In other words, we must live life to the fullest in a series of very intentional present moments, discovering the mystery of God in every jot and tittle.

Less is more. Nothing can make our heart leap higher than a small kindness or unexpected sign of affection—and nothing can give us a quicker massive heart attack than the pile of little memos that clutter our desk or refrigerator—the ones that, if we just shuffle the stacks every couple of days, we feel like we've gone well above and beyond the call of duty. Unless you are the leader of the free world, these little sticky notes are pretty dull and ordinary, and yet they level such daunting power.

In this drawing of Thérèse washing dishes, steam rises like incense in praise of the ordinary. She elevates the dish, perhaps searching for some sign of God in its squeaky clean surface. Thérèse believes that something as mundane as picking up a pin, if done with love and clarity of intention, can save a soul. When most of us mere mortals, however, reflect back at the end of the day, we have nothing more to show for ourselves than a series of routine moments that presented us with some big and some small challenges. And in those moments, we chose between two distinct options: Did we numb ourselves into an eternal state of boredom and frustration—or did we look for God in the thick of it all and enliven our tired spirits with new awareness of the Spirit's presence then and there?

Our incarnate God goes to great lengths to show us that one of the big responsibilities of being human is entering into the ongoing creation story. Most of us aren't summoned to do great and heroic things. In fact, our biggest accomplishment some days is removing those stale French fries from the upholstery on the driver's seat of the car. At other times, of course, our accomplishment can be much bigger: we're charitable to the co-worker who makes us crazy, or we make it through the afternoon without a cigarette, or we refrain from screaming at the kids. Stroke by stroke and dish by dish, we enter the small stream of the ordinary as it flows to that great ocean where everything is grace and all of life is touched by a sacramental spark of the Divine.

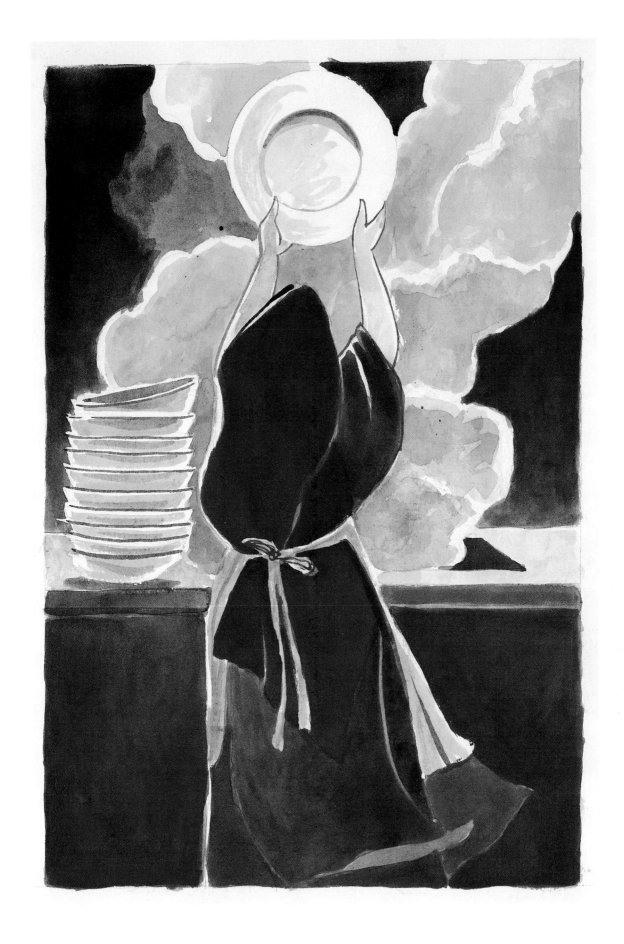

12. The Chasuble

I feel in me the vocation
of the warrior, the priest, the apostle. (SSC192)

As part of her personal mission in life Thérèse prayed for priests, but she also envied them their daily opportunities to consecrate and touch the Eucharist. Because women were not allowed to go beyond the altar rail at that point in church history, Thérèse loved her job as sacristan; it put her in contact with the sacred objects and liturgical vessels that only priests were permitted to touch. And ever the creative spirit, she knew that art and liturgy are ways in which we give physical form to unseeable mysteries. Thus, using watercolors, she illuminated missals and holy cards with beautiful letters and swirling vines. Using oil paint, she hand-painted priests' stoles and decorated chalice veils, covering these objects—objects that could be handled by only the consecrated fingers of men—with very feminine flowers and birds.

After her father's death, Thérèse cut up her mother's wedding dress and used the material to make a chasuble on which she painted a large cross. In the heart of the cross she placed a favorite recurring image: the suffering face of

Chasuble pt by Thérèse on her mother's wedding dress

Jesus. This image reminded Thérèse of her father's last days following a series of severe strokes, and of her anguish over his eventual death. In the process of sewing and painting, Thérèse brought forward from deep within herself a visual metaphor for her grief that helped her befriend her sorrow. In this way, she lived out the words of Eucharist: "Do this in memory of me."

It takes great courage to go to those painful places within, but doing so always results in gift. In fact, it is more fearsome not to go at all. If we look hard and listen attentively we can always discover blessings on the altars of our brokenness. From within her own painful places, Thérèse created an unconventional way to make Jesus as real as bread and wine—and thus was liberated beyond ritual ordination. In this drawing, Thérèse holds the chasuble like armor for the spiritual warrior she had become, like a vestment for the priest she had ordained herself to be.

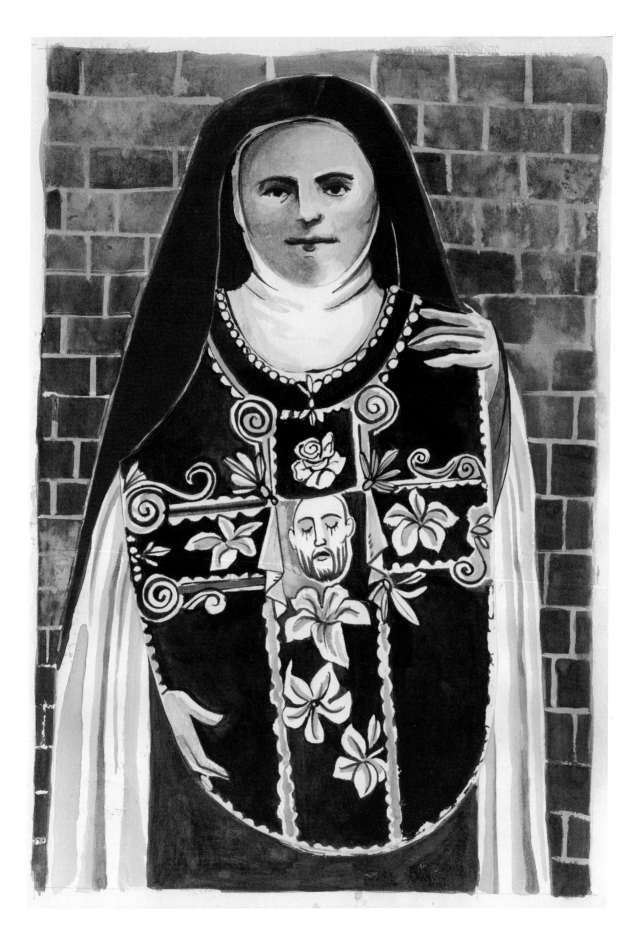

13. Joan of Arc

When reading the accounts of the deeds of French heroines,
especially Joan of Arc, I had a great desire to imitate them
and it seemed I felt within me the same burning zeal. (SSC72)

From the time she was a young girl, Thérèse had great affection for Joan of Arc, who seemed to inspire in her a sense of her own greatness. She always knew she was bound for glory, but in a different way than the dramatic circumstances of Joan's life. Instead of leading an army to victory on a valiant steed, Thérèse remained a hidden soldier with a personal mission of saving souls. Instead of charging through France with a sword, Thérèse remained unknown and hidden, wielding a far mightier pen. Instead of burning at the stake, Thérèse died a slow and agonizing martyrdom of tuberculosis. Still, under the skin, Thérèse and Joan were sisters, kindred spirits who died tragically and young, leaving legacies that touched chords deep in the psyches of Christians everywhere.

It's important that we have faith heroes but even more important that we listen to what they tell us. We choose our hero-companions much as we choose our friends. We are mysteriously drawn to them, perhaps hoping they will fill a certain void in our souls. They are teachers and guides on our journey toward greater self-understanding. What we learn from them about faith is healing balm for the wounds we suffer in our battles; what we learn from them about hope fires our dreams.

Thérèse mentions Joan at length in her autobiography and composed poems about her. She also wrote two plays that were inspired by the life of Joan, which she staged and starred in for a captive audience of nuns. When she was dying and in the throes of intense physical torment, Thérèse wrote a poem about being a warrior on the battlefield, a warrior who would die singing. In her own way, she had become another Joan of Arc waging battle on a different front. Today these soul-friends, Joan of Arc and Thérèse of Lisieux, are the patron saints of France.

Jeanne d'Arc

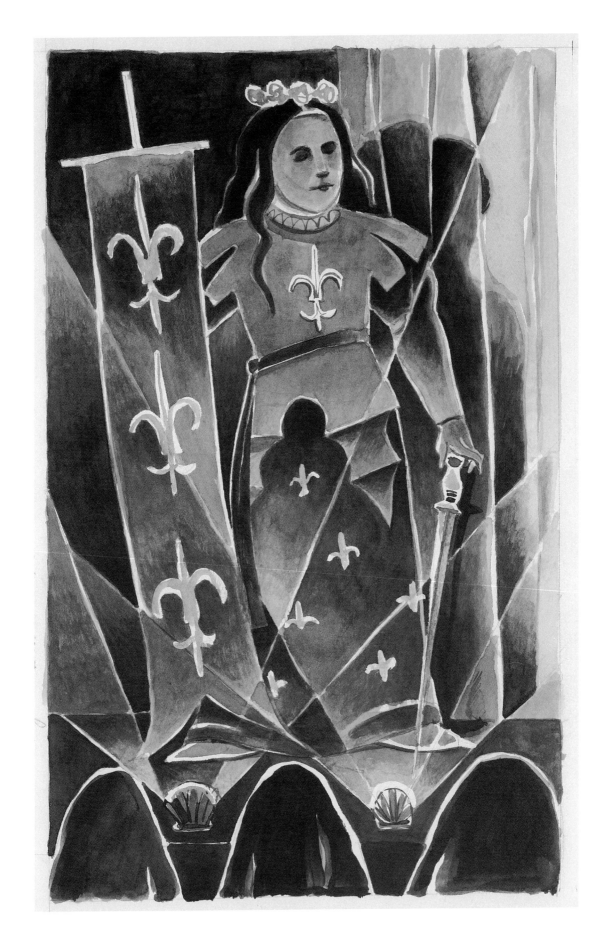

14. Charity toward All in the House

I understand now that charity consists in bearing with the faults of others, in not being surprised at their weakness. (SSC220)

Not that I hold old grudges or anything . . . But in my early days of formation, when I hadn't yet perfected the virtuous art of rising in time for morning prayer, a big muckety-muck in the order suggested that perhaps I was in my room "being creative" when the schedule was posted. He talked as if creativity were a subversive disorder, which I suppose it was in the old days of community when adhering to schedules and uniformity was held up as normal behavior. Instead of getting into therapy, as I did at the time, I wish I'd reacted the way Thérèse did when she slept in chapel: she simply said that sleeping in chapel didn't distress her because parents love their children asleep or awake.

There certainly were some prickly thorns in the Little Flower's garden. The nun who sat

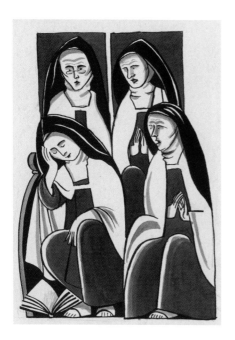

behind Thérèse in choir, for example, annoyed the hell out of Thérèse by making clicking sounds with her teeth. There also was a tough nun who handled the laundry, who called Thérèse a big nanny goat incapable of manual work. And there was the older sister whose needs Thérèse took upon herself to meet as a personal mission— helping this sister from chapel to dining room. Bent over with crabbiness, this nun constantly complained that Thérèse guided her either too fast or too slow. And then there was the biggest pain in the convent, the one that could clear a room quicker than a bomb scare. For this sister, Thérèse saved her brightest smile.

It's often said that the people who should be canonized are actually the ones who have to *live with* saints. But this wasn't the case with Thérèse. She had a natural ability to rise above the oversensitivity of youth to get down to the business of accepting others where they were—and it takes remarkable self-assuredness to pull that off. Thérèse took the challenges of living with disagreeable personalities and, through her patient bearing of their faults, learned charity. Thus, awkward annoyances were turned into opportunities for patience and kindness. Rather than taking it personally, Thérèse smiled; rather than holding a grudge, she let it go; rather than cowering in fear, she loved. Perhaps her aunt, Visitation Sister Marie Dosithee, taught her one of St. Francis deSales' best lines: "Make friends with your trials." Creative spirits have no other options.

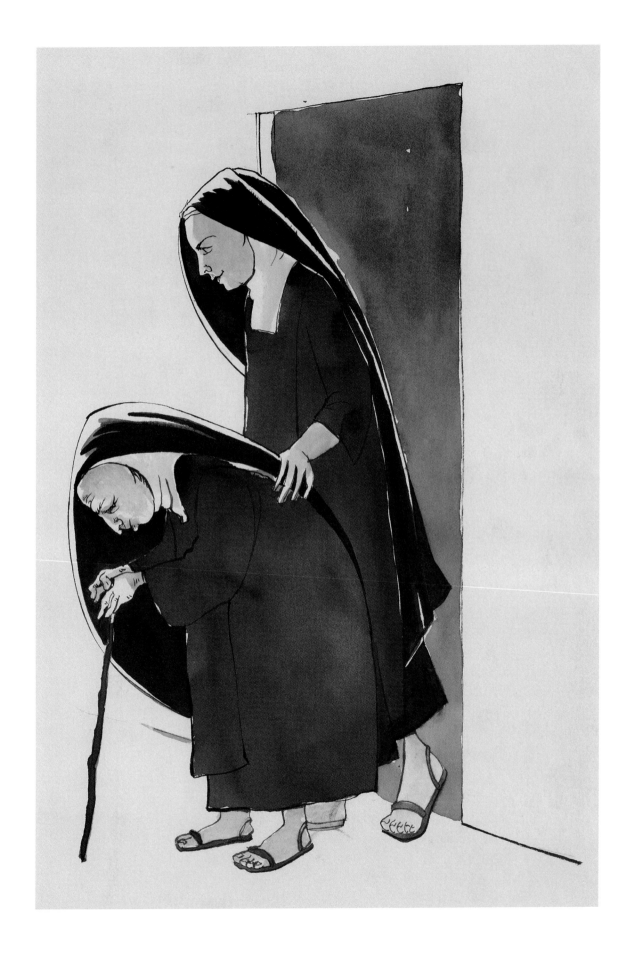

15. Elevator

I wanted to find an elevator which would raise me to Jesus
for I am too small to climb the rough stairway of perfection. (SSC207)

Elevators were a relatively new invention when Thérèse wrote this famous metaphor to describe her humble attempts to soar to God's arms. It was the perfect image for her "little way" of spirituality, one that celebrates littleness as the best means to holiness. I'm no Moses on Mt. Sinai, but it's always been my experience that climbing the heights, even modest ones, leads me directly to my depths. It doesn't matter how we get up there, the promise of transfiguration always awaits.

One day, several months after my mother's death, I visited my father who was living alone in our family home. While Dad went out for groceries that afternoon, I decided to make a small pilgrimage—a simple climb up the stairs to the bedroom where Mom had so recently died. With prayerful attentiveness, I mounted each step, aware of late afternoon shadows and waning autumn light. Slowly, deliberately, I walked down the hall, entered the room, and sat in my mother's rocking chair where she so often prayed her rosary and reflected on her life. There, in that holy place, I prayed my way into the silence, covered with the brilliant orange of an autumn sunset, the light creating blocks of golden color on the flowered wallpaper.

What did I expect to discover here? What was this mini-pilgrimage all about? I wanted to see the world as my mother did; I wanted to wrap myself in the coziness of her view.

With a final blaze of orange, the evening darkness set in and fell across the bed my parents shared for forty years. As a little boy, I climbed into that bed many times on dark and scary nights. I sat on it with my brothers and sisters as we shared the stories of the day with our parents. And just a week before she died, my mother lay there, and I beside her, and we talked about her funeral and her ideas of heaven. (She wasn't afraid, she told me. Certainly not as afraid as I was.)

As the lightshow ended and darkness settled into the room, neighbors across the street returned from a trip with another couple, and I listened to their laughter and farewells through two panes of glass. I then walked back downstairs to wait for Dad and groceries; to cook dinner; to savor the memory of late autumn sunlight that I had seen on this small pilgrimage to the heights— that would enlighten my heart forever.

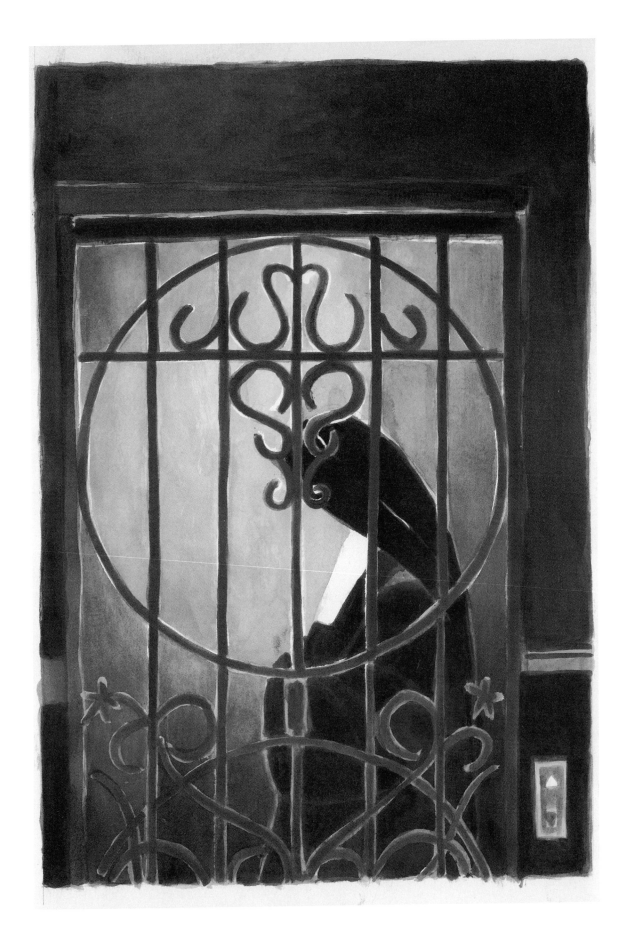

16. The Tabernacle

It is not to remain in a golden ciborium that He comes down to us
each day from heaven; it's to find another heaven
infinitely more dear to Him:
the heaven of our soul. (SSC 104)

I recall watching cartoons as a kid and loving it when I'd see a house that appeared real small from the outside but once inside, the hallways appeared to stretch for miles, giving the cat plenty of room to chase the mice. I began to see the tabernacle in church that same way. I'd sit through Latin Mass, usually bored out of my wits, and just stare at that thing, wondering if, on the other side of those unapproachable golden doors, there was a mystical, magical cartoon world, as in the Book of Revelation.

As someone who still waves hello at holy pictures and occasionally rubs the feet of statues, I don't find it too wacky that Thérèse would tap on the tabernacle door to see how things were going in there. She was simply seeking comfort in her trials, and knocked on the door, trusting it would open.

Like Thérèse, I bought all the stuff I was taught as a kid. I kissed my missal when I dropped it; I walked all the way back to church if I forgot to dip my fingertips into the holy water font on my way out the door; I practically choked to death every Sunday, rolling my tongue backward to pry the communion wafer from the roof of my mouth so it wouldn't touch my teeth. When sirens would whiz by the school, I would pause, with the rest of the kids, bow my head in prayer for the cops, the firefighters, or the ambulance driver, and the victims they were racing to help.

Sure, a lot of that stuff seems overly pious, and eucharistic theology since Vatican II has pointed us in a less privately devotional direction, but learning these things at such a formative age instilled in me a sense of God's very real presence in the world. And once we grow out of the thought of God locked up in a fancy breadbox, it's not that big of a leap to start seeing God present in other, grander tabernacles: the ones within our hearts and behind others' eyes.

In one of her mystical poems, Thérèse refers to herself as a living monstrance. In another, she wants Christ to make a nest for her in the ciborium. While conventional belief at the time may have centered on a small golden box imprisoning a remote and unapproachable God, Thérèse the poet and prophet saw it somehow differently. God was as close as a knock on the door, and revealed to her the vast expanses and endless hallways within herself.

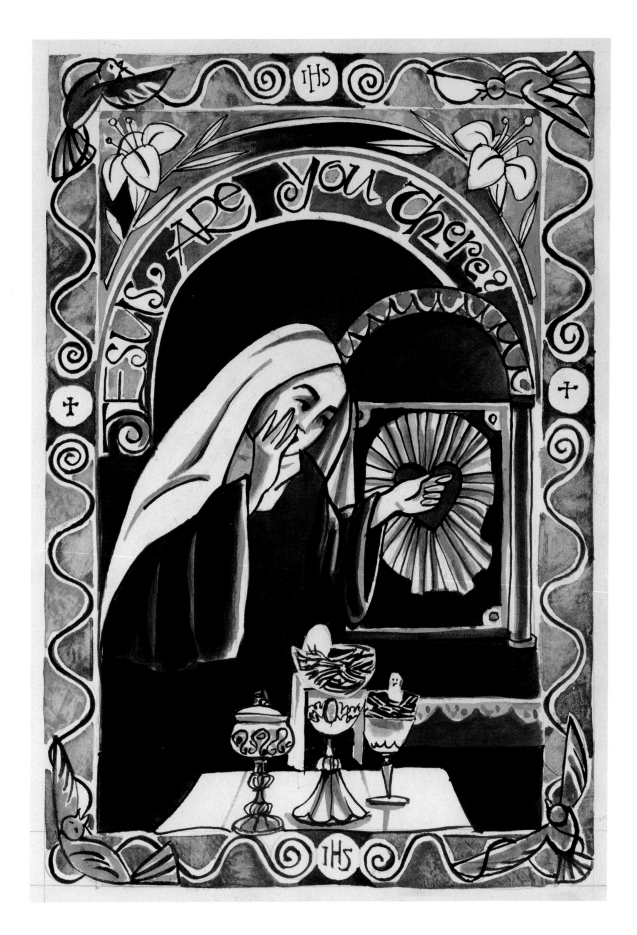

33

17. Writers' Seminar

With the virgins we shall be virgins;
with the doctors, doctors; with the martyrs, martyrs,
because all the saints are our relatives. (LC93)

Here they are, three Doctors of the Church writing their hearts out at a heavenly writers' seminar. We see John of the Cross, a patron of poets, who used imprisonment to his advantage and turned his dark night of the soul into great art. John, in fact, was one of Thérèse's chief spiritual fathers and mentors. We also see Francis deSales, patron of writers, who wrote a couple of great classics of spiritual literature and at least a billion letters of spiritual direction to people in the world. He appears in the basilica in Lisieux in a row of windows depicting Thérèse's favorite saints. And between these two, we see Thérèse herself, writing in her journal, undaunted by her auspicious company.

Saints lead us to other saints, just as writers and artists lead us to their own models and mentors. If we want to fully understand what makes a favorite artist tick, we need to explore his or her loves and inspirations. Copying the work of the masters is a time-honored method of learning to draw and paint. We learn from those who went before us, using what we need in the development of our own personality and style.

Reading about Joan of Arc helps us understand Thérèse's warrior spirit. Reading about Francis deSales helps us understand Thérèse's love for the little virtues and her optimism. Reading about John of the Cross helps us understand Thérèse's ability to turn deep interior turmoil into mystical poetry.

What's most important in all this is that Thérèse's regard for these saints never deterred her from being a unique individual. She took small elements from each of her inspirations and created a whole new masterpiece—her own self.

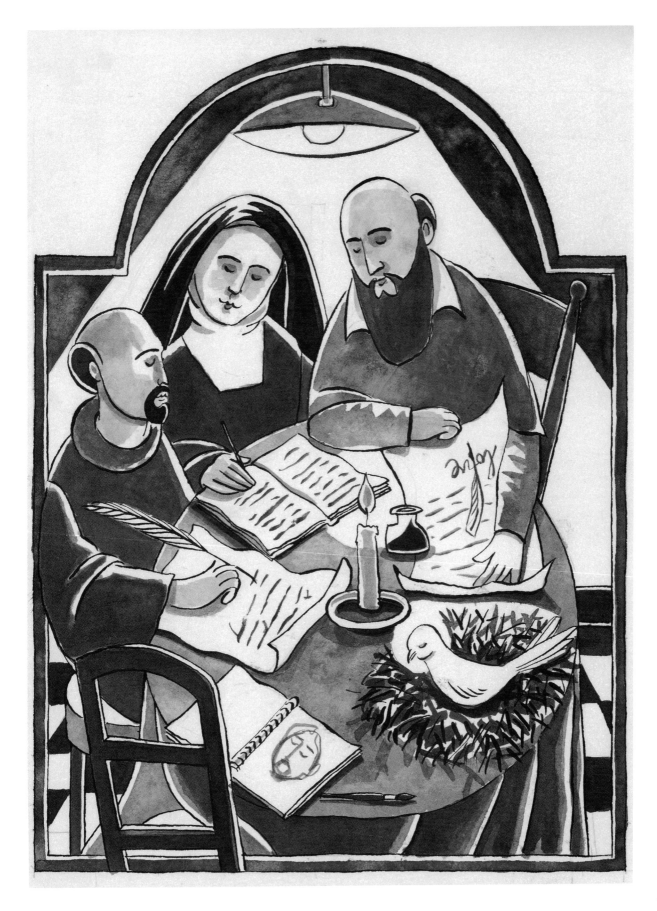

18. Writing Poetry with John of the Cross

*Jesus does not demand great actions from us
but simply surrender and gratitude.* (SSC188)

Thérèse wrote her first poems at the request of one of the nuns with whom she lived. After her initial protestations that she wasn't a writer or poet, she obediently set her mind and heart to the task and became hooked. Thérèse concluded that the ideas and inspirations floating around in her head were not hers to keep; rather, they were the whisperings of the Holy Spirit who needed to use her to convey a message. Thus, Thérèse wrote out of love and personal fulfillment. She saw her poems as gifts to the community, not as a means of winning approval.

When we engage in any creative prayer activity, we collaborate with God, acting as co-creators in the ongoing creation story. And you can't push it! Inspirations are only free to come forward when we don't force them. Like God, they are on a schedule totally different from the ones we have in mind for ourselves. Thérèse, for example, often composed poems in her head while mopping the floor or washing the dishes. Later, in the one free hour of time she had each day (the Carmelites ran a tight ship), she wrote them down on paper. My own best inspirations come forward when I am sitting quietly with my coffee first thing in the morning. Often, they arrive unannounced when I am out for a walk or driving the car.

We need to keep our eyes and ears open at all times, ready to receive these annunciations when they come. How to do that? The same way we learn to love: by just doing it. When we lose ourselves, we find ourselves.

PArAffin Lamp
- worked badly
- only light when she
 wrote at night.

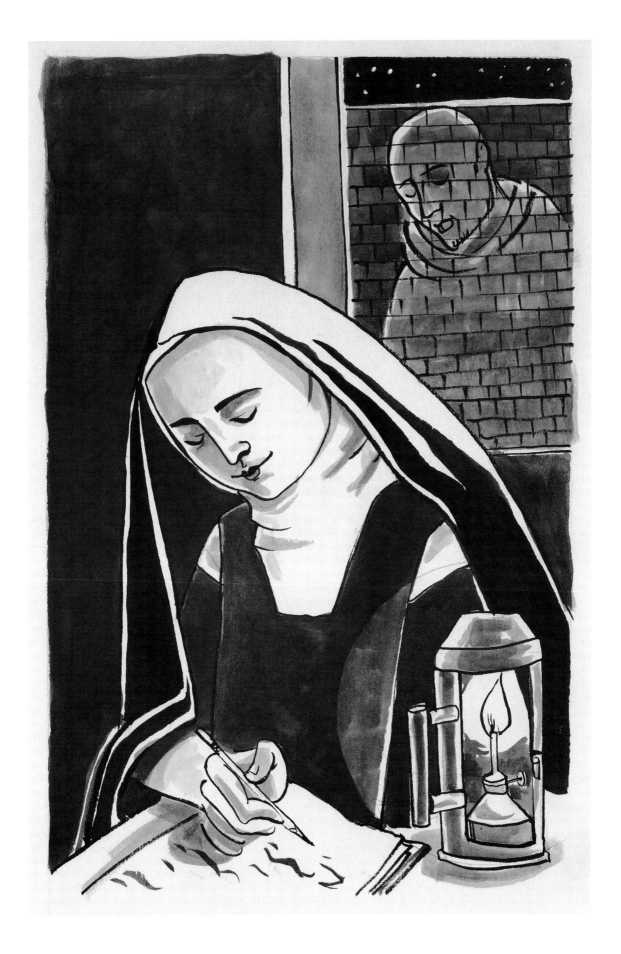

19. The Garden Within

In you, under my coarse brown habit
I find ring, necklaces, and jewelry,
gems, pearls and brilliant diamonds.
Canticle of Céline

I am writing this in a garden, sitting in a tar-splattered plastic chair next to a broken barbecue grill. The ground is covered with leaves that I've been meaning to sweep up all summer. And growing from the brick wall behind me is a network of pipes painted battleship grey. If all goes as usual, those pipes will soon emit loud, obnoxious noises to drown out the melodious sounds of birdsong and police sirens. It ain't much but it's home.

Gardens have mystical significance in art and poetry. They are meeting grounds for the

sacred and the profane. As we all know from the Genesis story, the first humans frolicked in naked freedom until that little incident with the serpent. Also, the Annunciation of Christ's birth has been shown in countless gardens dotted with flowers, each bearing its own symbolic significance. And the Resurrection is often depicted in a verdant springtime garden where Christ whispers Mary Magdalene's name and commissions her to be the first person to preach the Good News.

This meditation drawing was inspired by a canticle that Thérèse composed for her sister, Céline. Written in the same spirit as Daniel's Canticle, which is recited in the Divine Office, and as St. Francis of Assisi's Canticle of Creatures, this canticle celebrates the abundant gifts of nature that Thérèse recalls so fondly from her childhood. Closed off from them now behind high brick walls, she stored these gifts from God as cherished memories "beneath her coarse brown habit." She herself was the greatest of all these treasures, and she gave herself as gift.

Memories of gardens bursting with light and color sustain us when we are in less spectacular settings, as Thérèse was in her cloister—and as I am now. I shift in my plastic chair, my feet propped on a ceramic pot filled with sand, old beer cans, and cigarette butts, and I wait—trusting that the Holy Spirit will honor me with a visit to my meager estate and help me forget the mosquitoes.

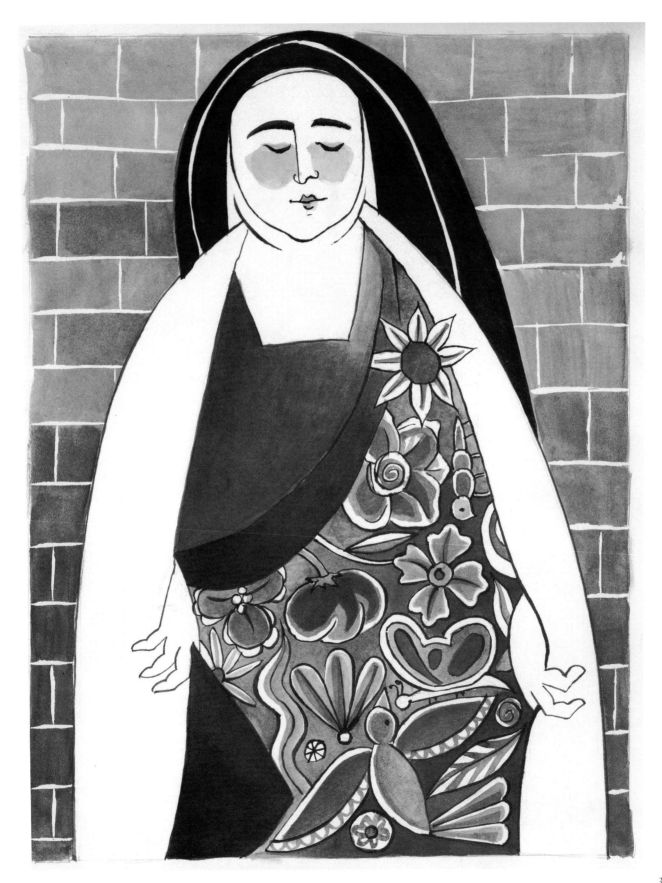

20. Eagle

I look upon myself as a weak little bird.
I am not an eagle, but I have an eagle's eyes and heart.
In spite of my extreme littleness . . . my heart feels within it
all the aspirations of an eagle. (SSC198)

Thérèse often spoke of herself as a sparrow flapping her tiny wings, unable to soar to the heights. I, too, have had the "birds of the air" bring me this very poignant reminder of my own littleness in the face of God's immensity and power. It all came back to me while working on this piece.

It was a cool morning with gusts of chilly Northwest wind, and I had just come in from an early walk down the road. I had taken a cup of hot coffee with me, and had stood on a bridge over the Wenatchee River to visit old friends. To the occasional passerby (always in a truck in these parts), I must have appeared as someone ready to jump into the icy rapids below, but I was

merely saying hello to friends, praying some memories, and rededicating my time and talents to God as a new workshop was getting underway.

The friends I greeted that morning are tall, sand-colored cliffs that rise high above the green Wenatchee. I climbed those cliffs a dozen years ago, when I was torn apart by grief over my mother's death. There, nestled in a rock crevice, I sketched and wrote and felt my heart get a jumpstart from the dizzying heights. I observed everything around me: the island in the river far, far below, and the billowing clouds above. And there, caught between the two, sat I, mourning in my sketchbook. Soaring just beneath my perch were magnificent osprey, gliding on air in broad, sweeping circles, their nests like control towers guiding them safely home after each circuit.

I recall being mesmerized by that moment unfolding itself before me, that epic drama in which I'd become a small player. Totally alone, far above the world, I never felt so much a part of life. With a broken heart, I'd climbed the heights and got a glimpse of the Promised Land. I was in God's country, higher than the tallest of the tall trees on the ground below, higher than osprey.

I, small bird that I am, soared with the big ones, knowing in my soul their freedom of flight, feeling in my heart their utter abandonment to the wind. The heights showed me what I knew in my depths—that everything is grace, that healing love abounds everywhere, that when we make

even feeble efforts to climb, God will send us osprey wings and we will abide in their shelter all our days.

I had not returned to those cliffs for twelve years—not until that blustery day when I huddled against the cold and walked to the Wenatchee River bridge. There that morning, with my cup of coffee and a dozen years' worth of new stories of loss and transformation, I once again greeted my fine friends—who filled my heart with song.

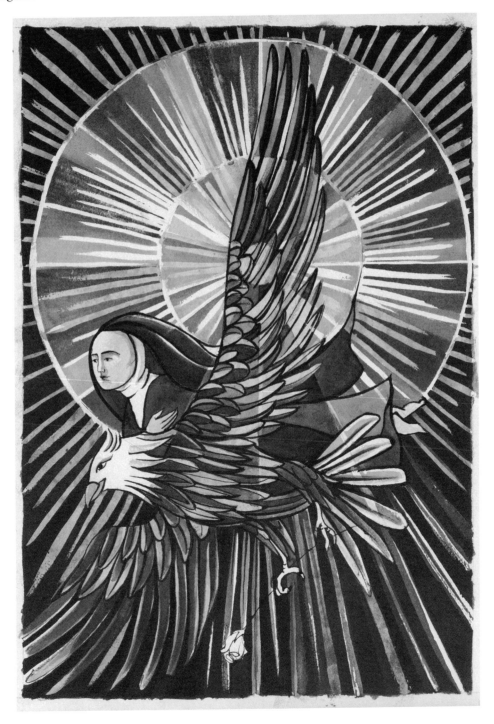

21. Mural Painting

*I am the very small brush He deigns
to use for the smallest details. (SSC235)*

Thérèse painted a mural in the convent chapel that depicts a flock of angels circling the tabernacle in a vast blue sky. And, as an added fun detail, she put her own face on one of the cherubs. Just another face in the heavenly crowd.

Viewers of my work are always curious about where my ideas come from. (Usually it's simple curiosity, but sometimes the question has an air of "Where in God's name did you come up with that and how do I get a prescription?") I tell people that as an artist I pay attention to the details. I size things up and take notice of things that others might not see: the shape of a shadow, the color of a patch of light, the lines of a room. I know that in paying attention to these details on the surface of life, I will be led to the life within. All details on the surface of life lead us to the life within.

There really is no such thing as an unimportant detail, and artists know this. Rather, we look at all those things that other people don't see, and we open them up for scrutiny. I love it when people say to me, "I never saw it that way before" or "I never knew I could see things that way." However the comments are phrased, they are about the same thing: in painting (or writing) the details, artists hold up a mirror to the human heart. It is as if their creative expressions validate the stories and dreams that are shared by all humans in our common experience of living.

Here's another, more mystical way of looking at it: because our God is incarnate, everything is grace. And when we pay attention to details, we uncover that fountain of grace that flows eternally beneath the surface of physical reality. It is around us, under us, beside us, and in us. Saint Francis deSales said it best: "God has imprinted on all created things His traces, trails, and footsteps."

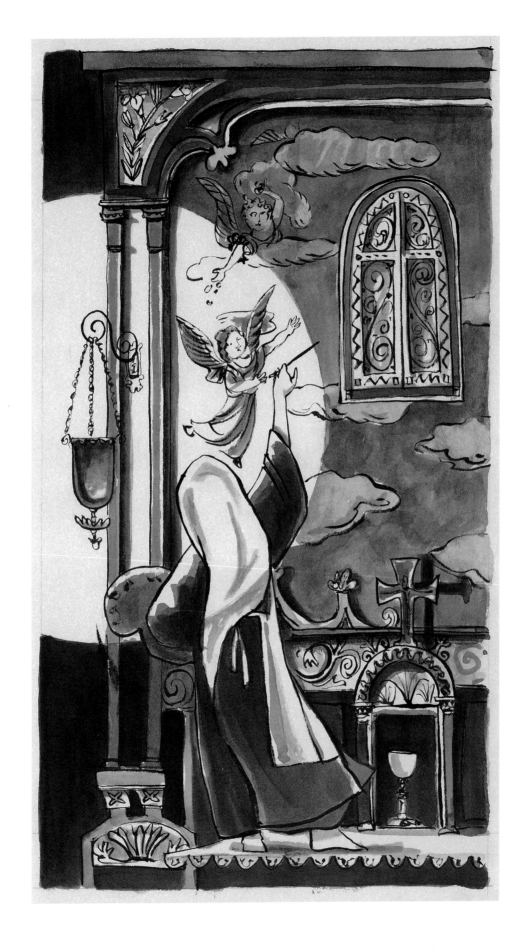

22. The Palette of the Divine Painter

Only the palette of the Celestial Painter
will be able to furnish me after the night of this life
with the colors capable of depicting the marvels He reveals
to the eyes of my soul. (SSC189)

Thérèse wasn't your stereotypical mystic, the levitating visionary who sees angels and saints and hears their voices. Rather, Thérèse shows us another kind of divine delirium, one that arises out of our little, ordinary selves. Although she was a monastic nun herself, hidden from the world outside her cloister walls, Thérèse teaches us that we do not need to live that kind of lifestyle to see the wonders of God. (Thank God for small favors.) Our souls do, indeed, have eyes and with

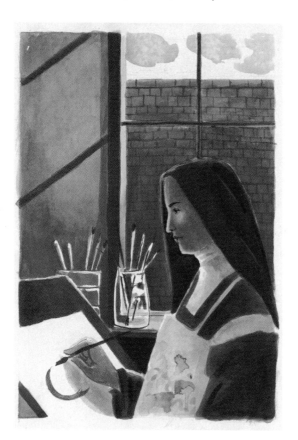

them we see wonders too deep for words to express—wonders that occur in our own particular worlds.

Whether I am working alone in my studio or teaching a class of students, my favorite moment is when everything becomes hushed and still. In those periods of blessed silence, the human spirit is listening to the small voice within, seeing with the eyes of its soul, looking deeply into the presence of God. Once the human spirit gets past the initial awkward steps, time disappears and nothing else matters but that next color or line. All the worries and self-doubt that initially threatened the work at hand—as well as the worries about kids, spouses, phone calls to be made—are reworked into feelings of self-acceptance and joy.

What is happening in these present moments? We are letting go of our need to be in control, allowing the hand of the Divine Painter to sketch us into a new creation. As Thérèse put it so eloquently, a canvas could never complain about being touched and retouched by the brush because it knows it is not responsible for the beauty that is unfolding on its surface, but rather the artist who guides the brush. We don't need to be artists or mystics to discover these graces, but we do need to make time and space for them in ways that work for us.

When we turn ourselves into a blank canvas or an empty sheet of paper, and come in

willingness, without a plan or preconception of what is going to happen, we open the place for healing to begin its work in our hearts. There we learn patience and gentleness. The Artist of Souls, whose sense of color and design is far better than our own, can begin to fashion us into something beautiful and new.

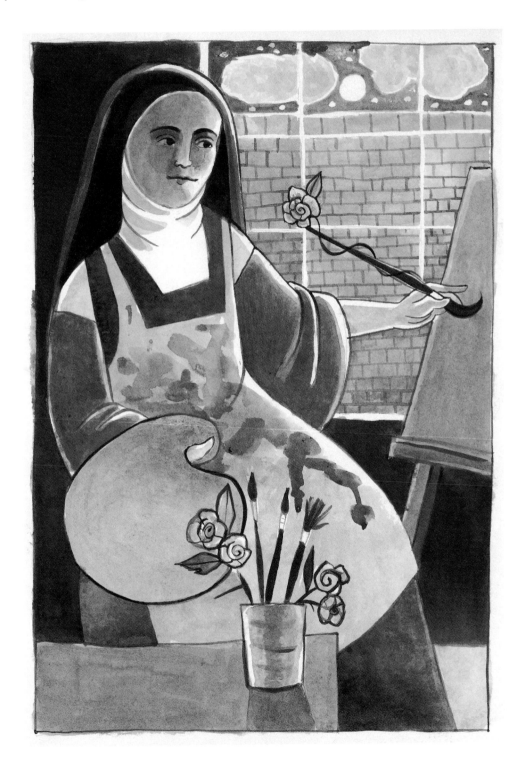

23. Thérèse Soars while Clinging to the Cross

I saw that He alone was unchangeable
and He alone could satisfy the immensity of my desires. (SSC175)

I n clinging to the Rock, Thérèse soars. This is the paradox of loving Jesus. I'm not absolutely certain who said it first (I think it was "big Teresa," the one from Ávila), but I adopted this as my life motto as soon as I read it years ago: "It is better to want what you have than to have what you want." This is probably the toughest lesson in the world for someone like me, a middle-aged baby in a crib grasping at every bit of color and light that passes over my thick skull. When will I ever learn, I ask myself time and

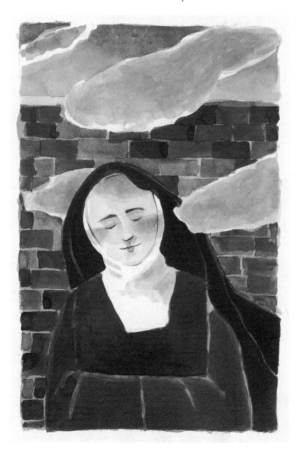

again, to stop chasing clouds, mere puffs and whimsies, and cling tightly to Jesus?

Everything, Thérèse tells us, is grace. When I was deeply mourning the death of my father, my wise friend Liz told me to take my grief and leave it *as a gift* at the foot of the cross. It was strange for me at the time to understand how such deep sorrow could be seen as a gift, but indeed it is. Rather than avoiding my pain and wishing it weren't there, I entered it and discovered its healing benefits. Since that time, grief has gifted me with a richer understanding of life and how to savor it.

Meanwhile, clouds accumulate over my head: the next painting; the next relationship; the next book; the next meal; the next community. They sweep by in endless profusion and, despite the lessons I learned at the foot of the cross, I still try in vain to pin them down. Then, I remember: I can know peace only when I am truly content with what I have now, where I am now. In that state of serenity, I can distinguish between those dreams that are the mere passing fancies of my own will and the ones that are truly my heart's desires, the will of God. In clinging to that I soar.

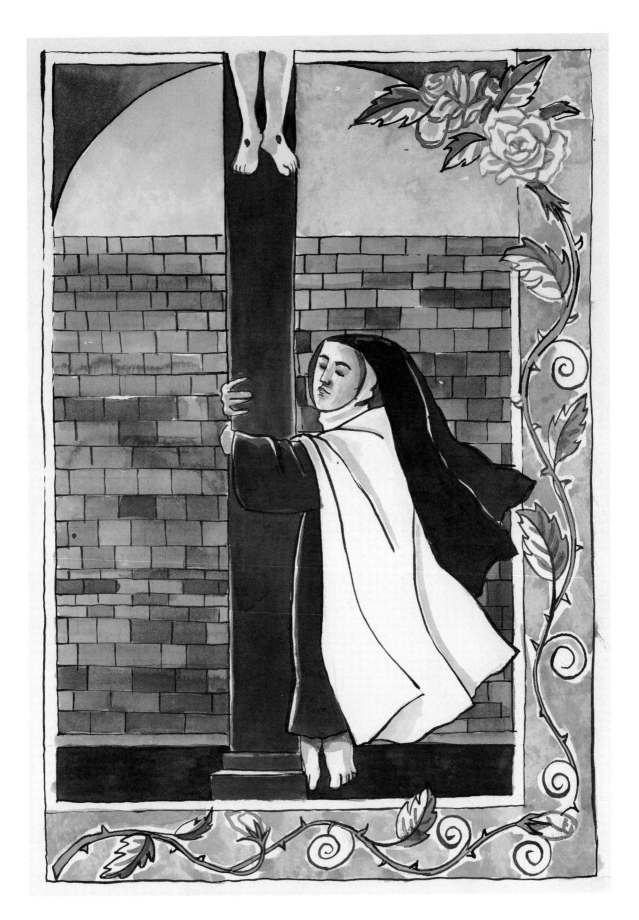

24. Living Flame of Love

The more the fire of love burns within my heart,
the more I shall say: draw me. (SSC257)

We all have moments of epiphany in our lives. We cannot force, fabricate, or make these moments appear on command. But we can sense their presence. We can live in readiness for them, allowing them to rise to the surface from our depths without fear or resistance. What we do about epiphany moments is simply permit them to happen, letting go with a great RUAH breath of the Spirit, the big "a-ha!" that comes, at long last, after all of our searching and questing. And they most often come through the back door, like the unexpected neighbor stopping by for a cup of coffee.

Thérèse's great epiphany moment was the discovery of her true and deepest vocation. The years she had spent in the monastery prior to this big revelation merely laid the groundwork. All the hours of silence, work, and prayer around the clock; the writing, the sketching, the painting; living into her routine and embracing the discipline of it; enduring the harsh austerity—all of it was merely the means to this one great epiphanic end that dawned on her like the fiery light of the sun. Her vocation was love: to love, to be love, to be loved, to be in love, to be inflamed with love. Nothing but love mattered.

Epiphanies (and love) happen because of who we are, not despite it. We are loved into existence by a God passionately in love with us, one Who constantly calls us forward from our brick-walled prisons. The fiery flame of love is a cleansing one, and consumed in it are our old selves: the memories and feelings that no longer nourish us; the relationships that keep us needy instead of nurturing us; the ideas about God that no longer suit our mature selves; the attitudes about life that don't help us freely advance on our journey home. All of it is offered up in the blaze of glory that is true love. We are works in progress, wondrous, indeed, to behold.

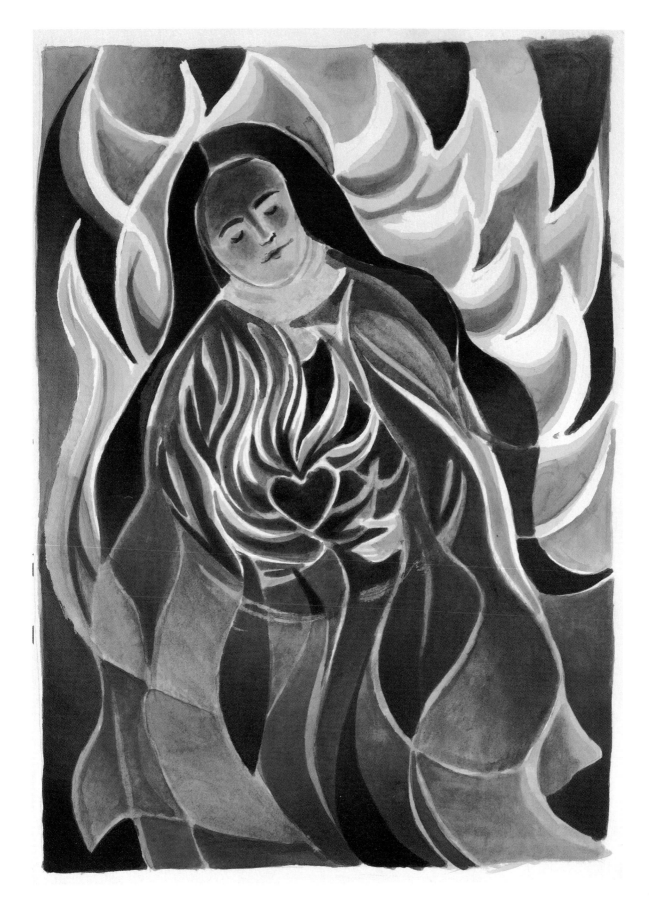

25. Thérèse and the Lord of the Dance

Since the time I took my place in the arms of Jesus . . .
nothing escapes my eyes;
I am frequently astonished at seeing so clearly. (SSC239)

My favorite Thérèse story . . .
In the last year of her life, Thérèse struck up a close friendship with a struggling young priest named Maurice, whom she never met in person. Through their correspondence, they became like brother and sister.

At one point, Maurice wrote Thérèse saying that he had done something unspeakably shameful and that he was groveling at Christ's feet for mercy. Knowing that Thérèse would soon

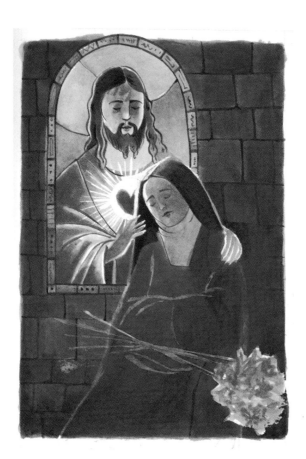

die, Maurice asked her to put her hand over Jesus' mouth when she met Him so He couldn't tell her what Maurice had done. She replied that not only didn't it matter to her what he had done (that's where we differ, I'm dying to know), but that he should stop groveling at Christ's feet. Rather, he should stand up because Jesus' arms were wide open, ready to embrace him.

To Thérèse, the Heart of Christ pumped as closely within as her own heart. And it was a heart brimming with love and mercy, not judgment or damnation. With such an image of the Sacred Heart, Thérèse completely dismantled within herself any concept of the need to be perfect in God's eyes. She could present herself to Him just as she was: a stumbling child, nowhere near perfection, who was doing the best she could. She found in Christ the tenderness of a mother who loves her children no matter what they do. She found in Christ the beloved Lover who told her that all would be well. She wrote of wanting to sit in His lap or rest her head on His chest. As she matured and came to see herself more clearly, she discovered the perfect way to remain small.

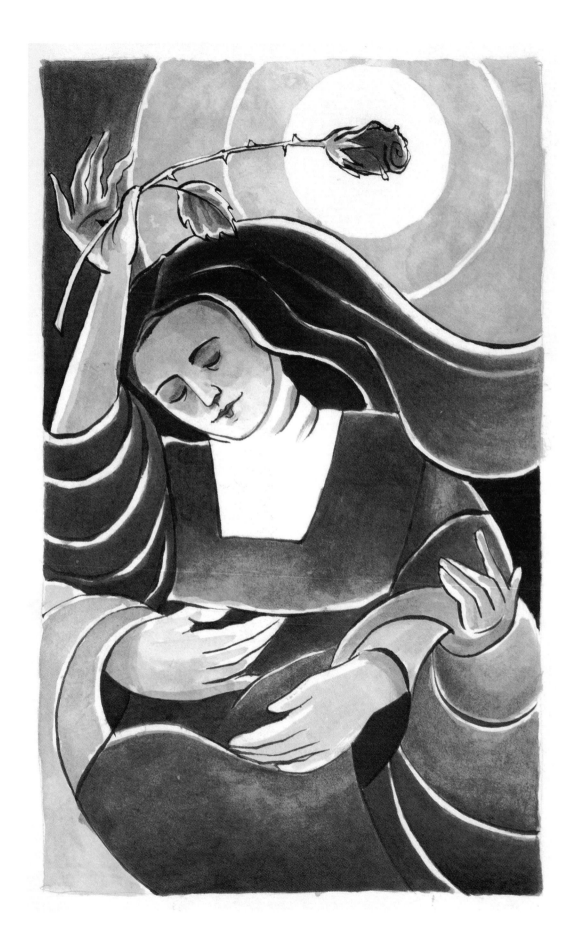

26. First Signs of Blood

I cough and cough! I'm just like a locomotive
when it arrives at the station;
I'm also arriving at a station: heaven,
and I'm announcing it. (LC42)

I love early morning light. I like it when it is still dark and quiet as a tomb inside the house, while outside the sun is gradually enlivening the world with the pink-and-pearly-gray light of dawn. As I fumble through the shadows, reaching for coffee, books, paper, and pen, I am glad that I forced myself not to hit the snooze button one more time—gradually grateful to be up, alert, and part of the world rising to the occasion of life once again.

Our souls are attracted to those times of transition when the dark of night grows into the light of day, when the light of day softens into evening. In such light, we actually look our best; our shadows aren't as sharp and abrupt as they

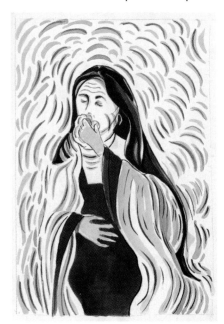

are at noon, and the light doesn't blind. Rather, in this light, it seems we can see the most complete picture of ourselves as the sum of our parts: light and shadow; beginning and ending; love and fear; panic and calm. There, in that soft-hued time, it all comes together.

It was in this kind of light that Thérèse discovered she had tuberculosis. There in the shadows of routine, while she was getting dressed, she looked at the handkerchief into which she had coughed during the night and discovered blood. Looking at this red stain of blood at the beginning of a new day, Thérèse knew she was going to die. She thought of her Savior and Lover, and took the blood as a sign that He would soon come: blood as distant warning; blood as sign and symbol; blood as wine-stained sacrifice. She would be a martyr of love, offering up this big thing just as she had offered up the little things.

Thérèse would see lots of blood and spit as the months wore on. Agonies of coughing and struggling for breath. Sharp pain and tortuous remedies for it. And in the midst of the hacking torment and oozing blood, Thérèse learned to live life fully, moment to moment. Instead of resisting the pain, she entered it like the warrior she had become, maintaining her gentle disposition and earthy humor. She lived in the perpetual light of dawn, accepted her transitory reality, and became her fullest, most beautiful self.

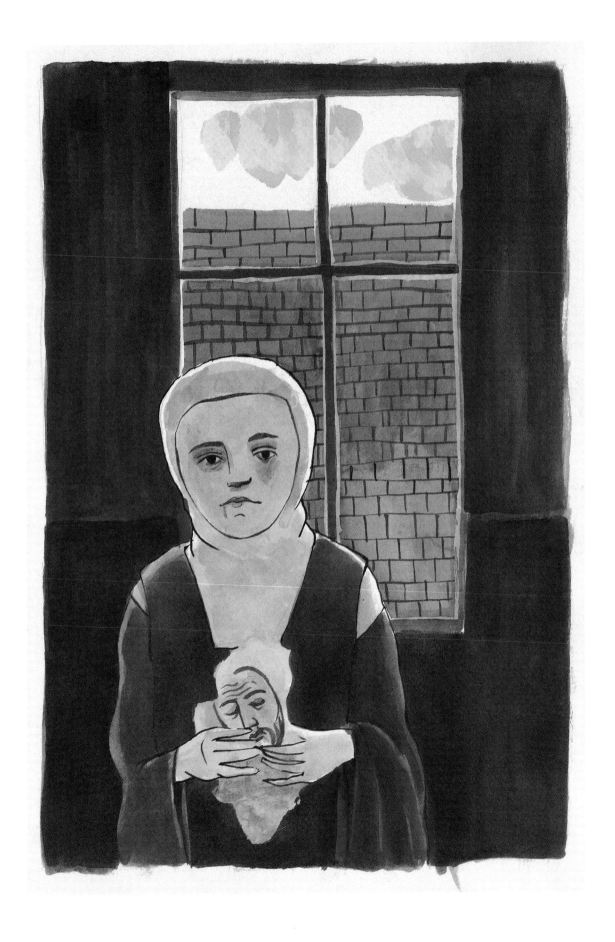

27. The Dark Night of Thérèse's Soul

The veil of faith is no longer a veil for me,
it is a wall which reaches to the heavens
and covers the starry firmament. (SSC214)

Sometimes the best way to see what's there is to take a penetrating look at what isn't there. First year art students learn this, and seasoned mystics live it time and again: the beauty of negative space—drawing the shapes of space around an object rather than drawing the object itself. You begin by drawing nothing, but soon enough the nothingness shows you what is right before your eyes. It's not a matter of denying the reality in front of you but, rather, of getting to that reality in a different way.

During the last year and a half of her life, Thérèse lived in an intense dark night of the soul, as most lovers of God do at some point in their lives. Because sharp pain comes with deep love, we can, indeed, love until it hurts—loving with such passion and intensity that we experience actual physical pain when the object of our affections is gone. So it was with Thérèse; in addition to the bodily excruciations of tuberculosis, she lived with a deeper, more encompassing dis-ease of the spirit: a broken heart, something she had lived with since her motherless childhood. She felt totally abandoned by God, and said it was like living in a land of an eternal fog that prevented the sailboat of her life from reaching its true home. Instead of concentrating on the desolation before her eyes, however, Thérèse searched for the God of consolation right next to it.

Writers, when they are blocked, keep writing, and artists, when they feel utterly abandoned by inspiration, continue to scribble—reminding themselves of what they know in their hearts: deep below the dry, drab surface of their skin, the waters of life continue to flow. In this same fashion, it is important that we keep on doing what we normally do when we are in the midst of the dark night of betrayal and rejection. Thérèse looked at the negative space created by her absent love, and carved into that space with pen and paper, writing poems and fishing for memories of sunnier days in the ice-cold river of her heart. She never denied her pain or pretended it wasn't there; rather, she smiled through it all and continued to crack jokes. Despite the commotion in her gut, she remained gentle and kind, finding fullness in the void.

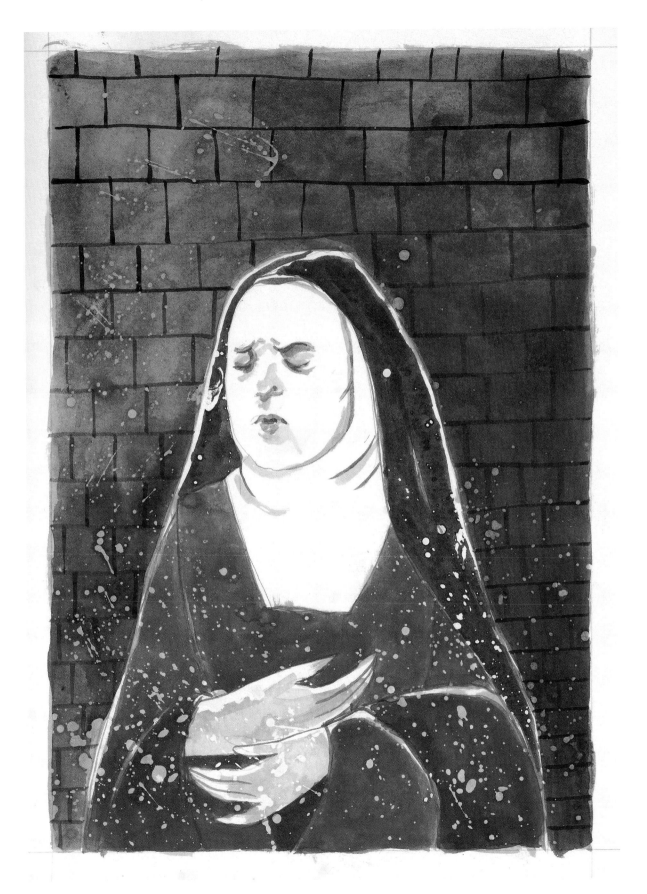

28. Thoughts of Suicide

*If I had not had faith,
I would have committed suicide without hesitation.* (LC 163)

One of the great legends associated with Christ's final agony, and one of the most beloved stations of the cross, is the story of Veronica: the brave woman who worked her way through the jeering mob and used her veil to wipe the blood and filth from the face of Christ. Her name means "true icon," and since she is not mentioned in Scripture, it is safe to say that she is the beautiful creation, the stroke of genius, of an ancient storyteller who simply wanted to bring a note of tenderness into the awful story of Christ's passion. In His gratitude, Jesus graciously left Veronica a gift in return: the impression of His face on her veil, painted with His own blood and grime.

Artist's renditions of this story abounded in Thérèse's day, and one of these became her favorite icon of Christ as her own suffering progressed. Pinning this image, along with holy cards of other favorite saints, to the curtain that surrounded her bed, Thérèse prayed, "Make my face resemble Yours," as she herself became the perfect sacrifice to God. For Thérèse, Christ's face became a bright red beacon in the dark night, leading her from the shadows of suicide and despair to the light of heaven. "Draw me," she begged, and she herself became a veil revealing the face of Christ.

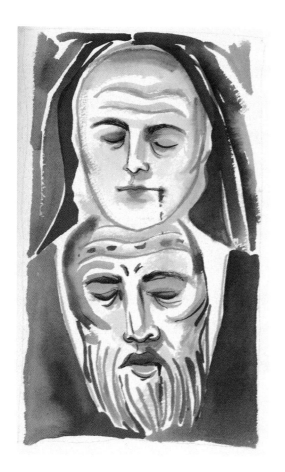

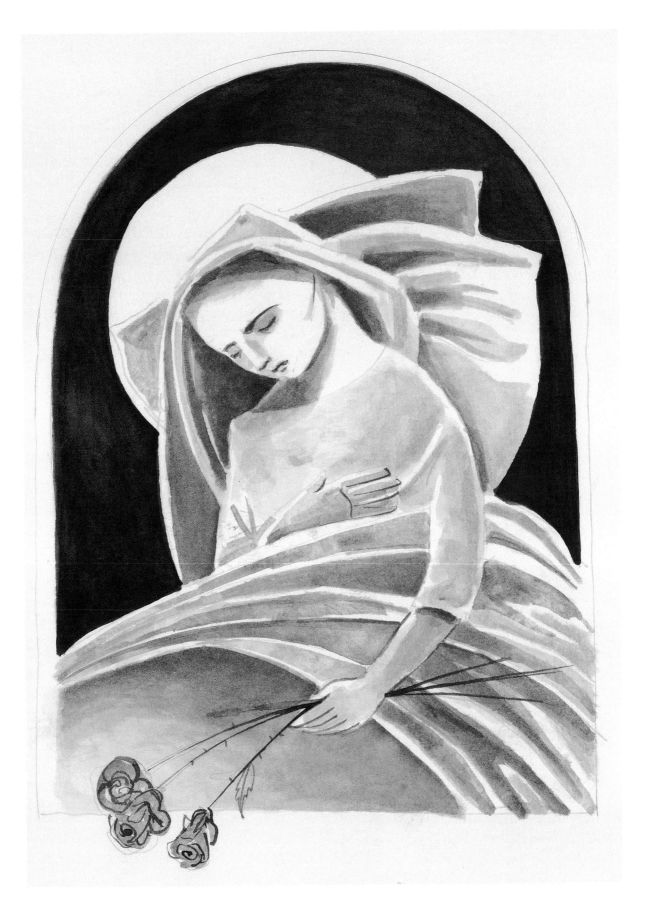

29. Jesus Comes to Thérèse

It's really through love that I am looking up at the sky;
yes, it's through love for God since everything I do,
my actions, my looks, everything, is done through love. (LC141)

A deathwatch is a strange, disjointing thing. Because I was present, along with my brothers and sisters and two aunts, at the deaths of both my parents, I've come to see the death-watch as a sacred rite of passage to new life—for both the person dying and those gathered around the bed. I will never be the same after hearing my parents' final sighs, the gentle "ruah" breath of God, that came after months of riding the roller-coaster of chemotherapy, bedpans, fevers, and wasting away.

The blessings that came with the misery of it all were this: I witnessed right before my eyes both the fragility and the strength of life, and I learned to live every present moment to the fullest. In those last months, all of our hugs were more intentional, our questions and conversations more poignant. We shared memories, made plans, and prayed our way into readiness for that inevitable journey home.

In the last month of her life, Thérèse's bones protruded through her back as tuberculosis invaded her intestines; with the use of only half a lung, she was slowly suffocating. Surrounded by her sisters, she spent her present moments watching and waiting for Jesus, her "Little Thief" who said He would come in the night, announcing neither the day nor the hour. All of the nuns present at Thérèse's deathbed witnessed—as I did at the deaths of my parents—the unutterable peace and beauty of His arrival, announced on Thérèse's suffering face by a smile and the gentlest of breaths.

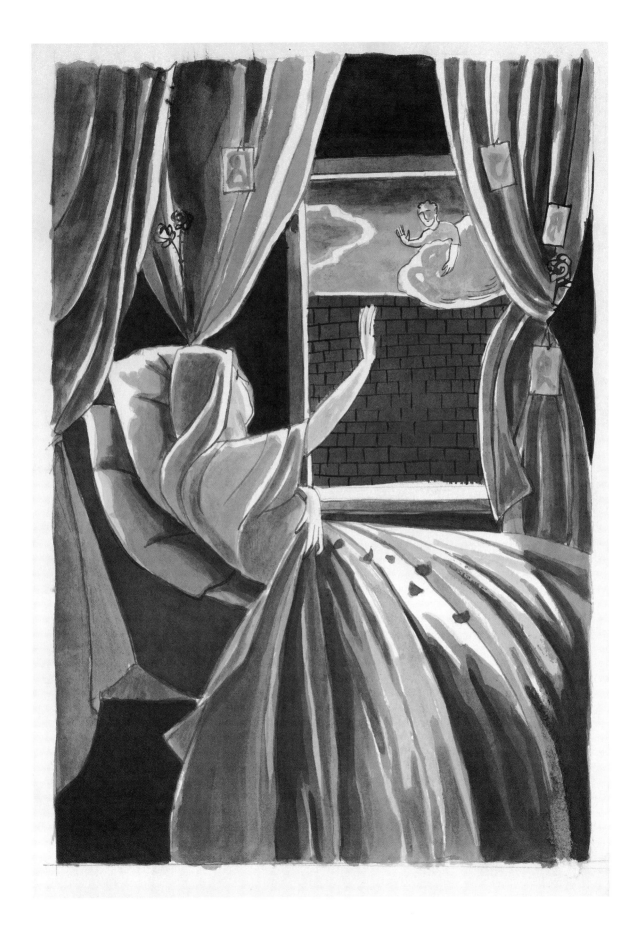

30. The Warrior Is Lifted from Her Bed

It is into God's arms that I am falling!
I'm afraid I have feared death. I am not afraid
of what happens after death; that is certain! (SSC268)

Jesus lifts His dying warrior from the battlefield. It is a young Jesus who comes for her, the Child Jesus, not the suffering face to whom Thérèse had grown so close during her illness. She is moving beyond that image now, to a place of light far from the confines of her earthly prison.

The bedsheets and curtain are twisted around Thérèse in a cascade of folds similar to a christening gown or a wedding dress—or a shroud. They are all the same, these sacramental garments—symbols of new life in which we clothe ourselves with the pure white simplicity of Jesus.

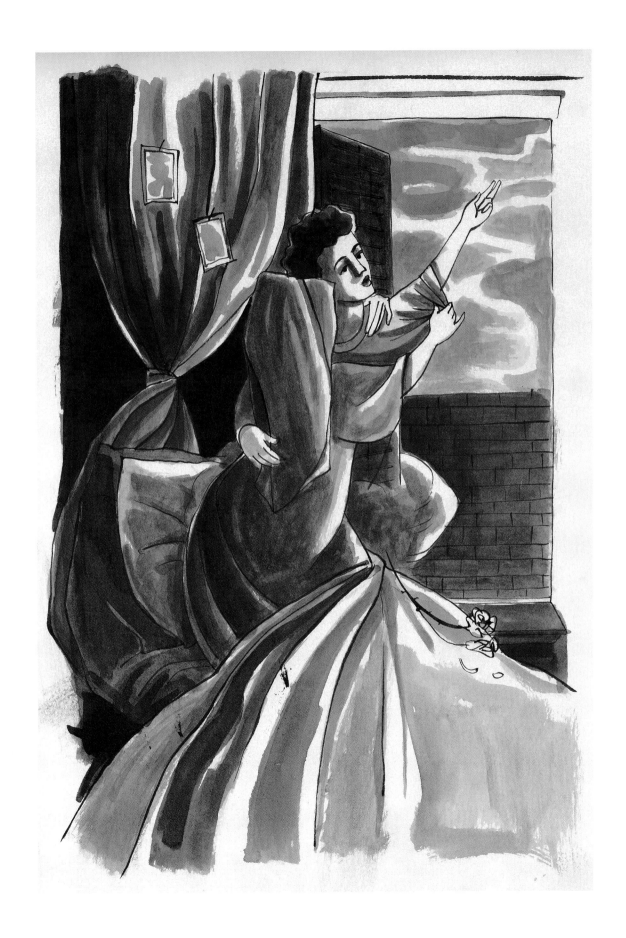

31. Over the Wall

I would go, my heart broken with sorrow,
and throw myself into Jesus' arms,
for I know how much He loves the prodigal child who returns to Him. (SSC259)

Saints and artists have this in common: while they may fear the unknown, they have no other option than to dive into it. They leap into love and immerse themselves in the mystery of it. They risk exposing their vulnerability, knowing that in doing so they will find strength.

Every choice for life that we make, no matter how big or small, removes another brick from the high walls around our hearts that hide the stars. Whenever we choose to create instead of destroy, to forgive rather than bear a grudge, to build rather than tear down, to change and adapt rather than cling desperately to the familiar, we dismantle the walls bit by bit, brick by brick. Whenever we choose life, we choose love and all that goes with it.

It all comes down to love. In love, Thérèse created a masterpiece of her life and slowly dismantled the high brick fortress that surrounded her. She fought the good fight and Christ, her Brother, her Father and Mother, her Friend, leads her home, free at last.

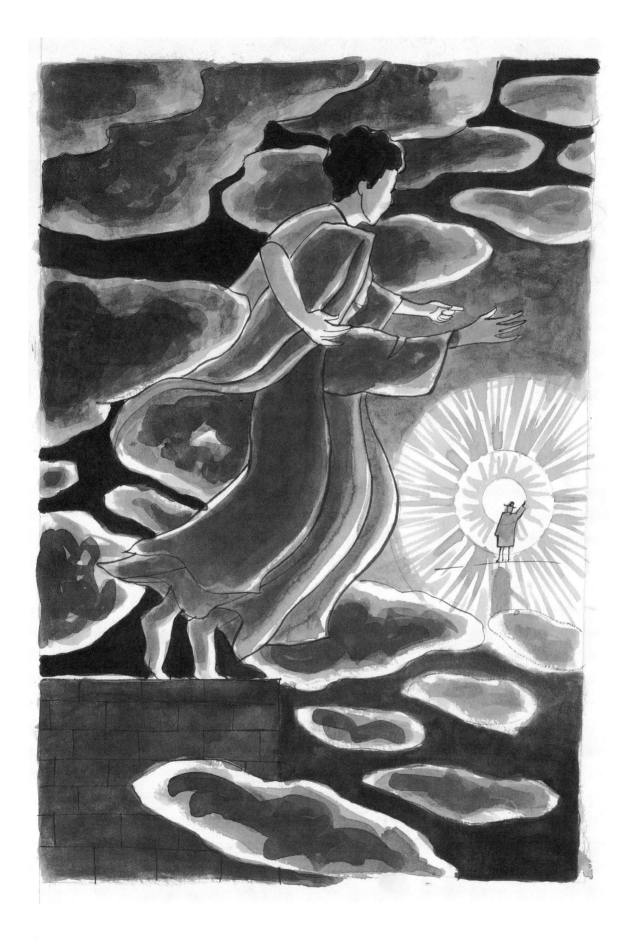

32. Heaven

I would like to run through the fields of heaven
where the grass doesn't crumble,
where there are beautiful flowers which don't fade,
and beautiful children who would be little angels. (LC199)

Heaven has been depicted in many ways in art and song. It's a banquet table where we feast with loved ones. It's a mansion with many rooms, one of which is being prepared for you right now as you read this. It's rolling green hills with sheep and familiar faces. It's an ocean of clouds like we see from the window of an airplane on a clear day. Streams of living water and constant brilliant light are recurring symbols for this state that lies beyond our grasp or comprehension.

Thérèse frequently spoke of her life on earth as being an exile from her true home, heaven. As she neared death, she talked about going to the "fatherland," very deliberately choosing this image that sprang out of her deep love for her own father, her earthly "king" who, more than anyone else, taught this motherless and sensitive child about love. When, at the age of fourteen, Thérèse told her father of her plans to enter Carmel, he picked a flower—roots and all—and gave it to her. So treasured was this symbol of acceptance that Thérèse pressed it in a book and saved it the rest of her life. In that simple gesture, Louis Martin honored his daughter's dreams, offered her the freedom to pursue them, and modeled the loving abandon of God. Naturally, Thérèse would relish spending eternity with such a parent.

We are given glimpses of heaven on earth but can see them with only the eyes of our souls. There is a stream of living water that courses its way through each of us, flooding our hearts with memories and our spirits with love. Glistening on the surface of this stream is light and in this light we see Light Itself, the Light that brightens the darkest corners of our deepest shadows. This Light reminds us that no matter who we are or what we do, ever, we are loved into life, always.

33. Shower of Roses

He is free to use me to give a good thought to a soul;
and if I think this inspiration belongs to me, I would be like the donkey
carrying the relics who believed the reverence paid to the saints
is being directed at him. (SSC234)

Thérèse promised that she would spend her eternity in heaven doing good on earth. She said she would return and help all those who struggle—her friends, her brothers and sisters—by showering roses on them, her metaphor for the good deeds she would send their way. Devotees have come to believe that after praying to Thérèse for a short time, they will literally receive roses in an unexpected and strange way. To others less enamored of Thérèse, the rose thing has always been silly and pietistic.

All I know is this: twice I received roses in odd ways when I have prayed fervently to Thérèse—and I'm not talking about praying with the little devotional novena books that people clutch in the communion line with their rosary beads.

But you know what else? Those two roses are not all that important in the big picture. In fact, I don't think about them that much anymore, like the "get well" cards we forget about once we're out of the hospital and dancing again. I just know that my roses were timely signs that went way beyond the realm of coincidence. I know that they were St. Thérèse telling me, "I'm here. I hear you. Hang in there. All will be well." And I believe this: those two roses were only several of countless other, more substantial flowers showered on me by a Spirit of Love much bigger than little old Thérèse—a Force of Love much bigger than I could ever imagine.

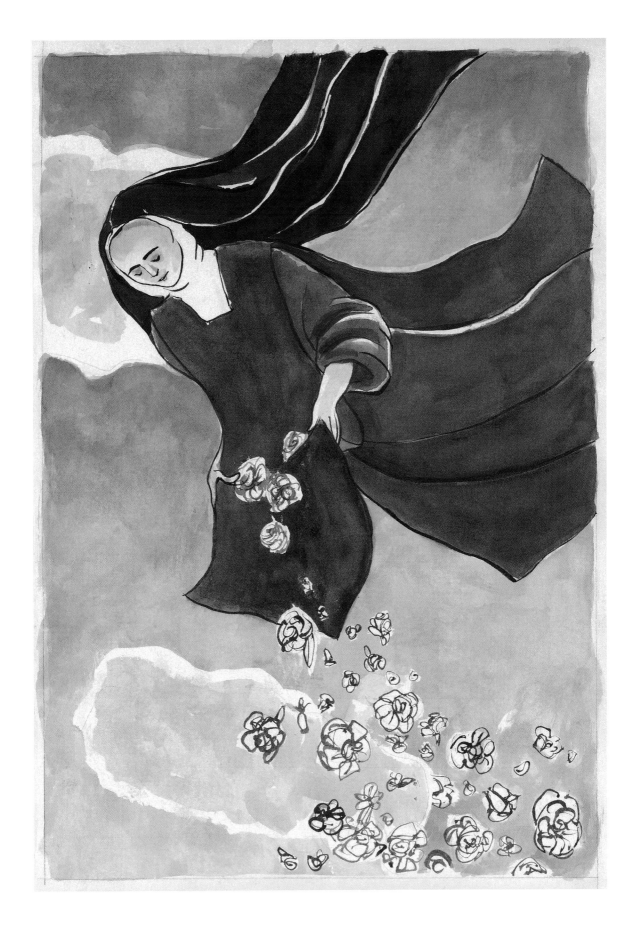

Conclusion

I understood that
love comprised all vocations, that love was everything,
that it embraced all times and places . . .
in a word, that it was eternal! (SSC194)

When I arrived in Normandy, the night before heading to the Visitation monastery in Caen, I stayed in a small hotel on Omaha Beach, the main site of the D-Day invasion. This sacred and hallowed beach seemed the perfect place to gather my thoughts as I began this last, most important phase of my French pilgrimage. It was the ideal spot to take a different look at the personal battles waged within my soul over the past several years, battles that the warrior Thérèse helped me confront.

After dinner with two friends, I walked alone on the beach, beginning at the large concrete monument that stands there in solemn majesty. I slowly climbed the steep cliffs, familiar from photos and films, where so many thousands of young men died for my freedom in an unimaginable frenzy of blood and smoke. I peered into a

May 31, 99

OMAHA BEACH
VIERVILLE 8 JUIN 44
SECTEUR
CHARLIE | DOG GREEN

German pillbox resting quietly on the side of the cliff and stared into the barrel of a rusty and useless gun. At the top of these cliffs, I slowly waded through tall grass blowing in a gentle wind and stared into the steely grey sky and out to sea. The light was silvery and sharp, the ocean deep and dark. And, most moving of all, there was not another living soul around me the entire time.

It was another ascent, another sacred pilgrimage I will never forget. I tried to imagine the horror of events that occurred there on June 6, 1944, fully aware of the irony of the present moment, the circumstances of my being there. I was standing above one of the most momentous battlefields in history, on my way to see the sacred shrines of a woman named the Little Flower, who also died too young on a very different kind of battlefield many years before. I thought about the thousands of soldiers, on both sides, who wore her medal along with their dog tags, and who implored her help on that awful day, as I did now.

I didn't cry, nor did I try to draw or write. I was too dumbfounded to struggle. The gentle silence was deafening. I thought of my parents, of other friends and guides who have died, of people once important who were no longer a part of my life, of family and friends back home, still alive, whom I loved and missed. I thought of the sweeping events of history in the world and Church since the time of Thérèse, since D-Day. Once again, the heights brought me to my depths and, with the eyes of my soul, I could see emerging a new vision of this pink, child-woman of a saint who drew me here, this towering symbol of gentleness and strength. Omaha Beach was, indeed, the best introduction I could have had to Lisieux.

Thérèse spends her days in heaven as a rose on the beach, befriending young, lost warriors and guiding us to God. Across the decades and miles, across the high brick walls of her monastery prison, she beckons. "Come with me and my orphaned heart will show you the Christ Child deep within. Come with me, and my warrior spirit will help you to fight gently the battles waged inside of you. Come with me, I will be a priest and teach you about reconciliation; I will be an artist and show you the healing grace that grows inside of you like a seed in an ever-green garden. Come with me into the mine of your heart, to Jesus, your own Jesus, and to Love. I will be your sister and your friend always."

the Rear of the Basilica of St Thérèse June 2 99 9:00 PM. MARTIN 2002